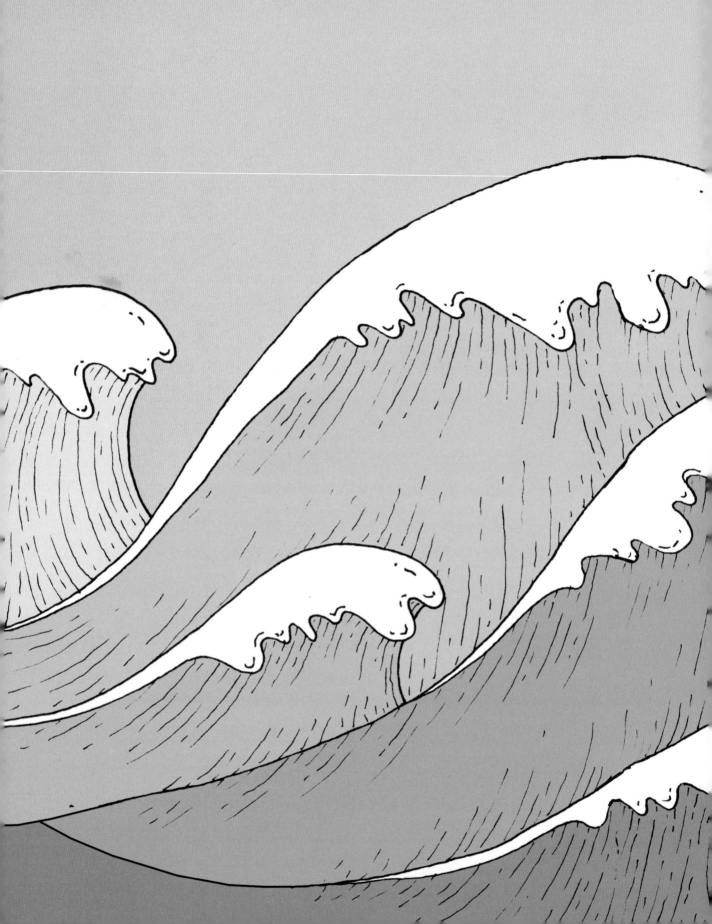

SEEING SCIENCE

AN ILLUSTRATED GUIDE TO THE WONDERS OF THE UNIVERSE

BY IRIS GOTTLIEB

CHRONICLE BOOKS

SAN FRANCISCO

FOR ALL THOSE WHO ARE CURIOUS—AND, OF COURSE, TO BUNNY THE DOG

Library of Congress Cataloging-in-Publication Data available.

ISBN: 978-1-4521-6713-8

Manufactured in China

Design by Michael Morris
Production Design by Kris Branco

10 9 8 7 6 5 4 3 2

Chronicle books and gifts are available at special quantity discounts
to corporations, professional associations, literacy programs, and
other organizations. For details and discount information, please
contact our corporate/premiums department at corporatesales@
chroniclebooks.com or at 1-800-759-0190.

Chronicle Books LLC
680 Second Street
San Francisco, California 94107
www.chroniclebooks.com

Contents

Introduction

BY IRIS GOTTLIEB

The bowerbird inspired *Seeing Science*. Nature's ultimate collector, the male bowerbird is a masterful architect of color-coordinated, sculptural nests comprised of sticks as well as collected man-made or natural objects, often all in the same color palette. Like the bowerbird building his nest, I collected snippets and specimens from across the scientific universe to make this book.

I have been investigating and documenting the natural world since I was a child. Introverted around humans, I befriended all sorts of creatures: mole crabs at the beach, a six-foot-tall plant named Bill the Weed, worms and fireflies in the backyard, a dead fish named Sleepy (who was already dead when we met), many identical gerbils over the years, and my current best friend, Bunny the Dog. This book allowed me to explore so many of the concepts I have been, to my family's loving irritation, asking forever. How many grains of sand are there on earth compared to stars in the universe? Why isn't all body hair the same length? Why is there high tide?

The scales of science are incomprehensibly vast, from quantum particles to the outer boundaries of the universe, and most of it is hard to actually see or touch. I have learned about the scientific world through drawing. Being able to *see* what's in front of me and translate it into digestible visual information allows me to grasp infinite, abstract ideas or microscopic interactions. Bringing these inaccessible systems to the human scale in a universal visual language makes the information easier to understand and beautiful to behold.

I am writing this book from a non-academically trained science perspective. Scientific truth is truly stranger than fiction, and it deserves to be explored, understood, and appreciated by us all, regardless of our formal education. I want to open up the world of complex science with art and metaphor and storytelling. It is my hope that this book makes science more accessible, less intimidating, and more magical to anyone who has a sense of wonder—and a sense of humor.

Life Science

The study of living organisms, including
determining what is living, and life processes

Anatomy
Biology
Botany
Ecology
Genetics
Microbiology
Neuroscience
Zoology

What Is Alive?
The seven criteria of living beings

Homeostasis
THE ABILITY TO REGULATE
AND MAINTAIN INTERNAL STATE

Metabolism
THE ABILITY TO TRANSFORM
EXTERNAL ENERGY INTO INTERNAL
ENERGY AND WASTE

Organization
COMPOSED OF ONE OR
MORE TYPE OF CELL

Adaptation
THE ABILITY TO CHANGE OVER
TIME IN RESPONSE TO THE
ENVIRONMENT

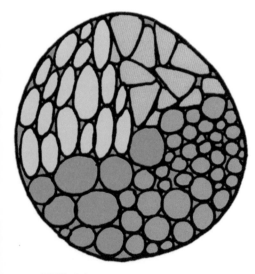

Response to stimuli
THE ABILITY TO REACT TO EXTERNAL STIMULI,
OFTEN INFORMED BY SENSORY ORGANS

Growth
THE PROCESS OF INCREASING
IN SIZE OVER TIME

Reproduction
THE ABILITY TO PRODUCE
OFFSPRING VIA SEXUAL OR
ASEXUAL REPRODUCTION

Evolution Pt. I

EVOLUTION IS THE PROCESS OF DEVELOPMENT AND DIVERSIFICATION OF LIVING ORGANISMS OVER TIME THROUGH THE MECHANISMS OF MUTATION, MIGRATION (OR GENE FLOW), GENETIC DRIFT, AND NATURAL SELECTION. THESE PROCESSES ALL RESULT IN GENETIC SHIFTS, WHICH IS THE BASIS OF EVOLUTIONARY CHANGE.

1. Mutation: RANDOM, UNBIASED CHANGES IN DNA. CAN BE CAUSED BY IMPERFECT COPYING OF DNA DURING CELL DIVISION OR BY CHEMICAL EXPOSURE OR OUTSIDE FORCES LIKE RADIATION

2. Migration: WHEN GENETIC DIVERSITY IS BROUGHT TO NEW PLACES OR POPULATIONS. IF FOOD IS SCARCE AND A POPULATION RELOCATES AND MATES WITH INDIVIDUALS IN THE NEW LOCATION OR POLLEN IS BLOWN BY THE WIND TO A NEW FIELD

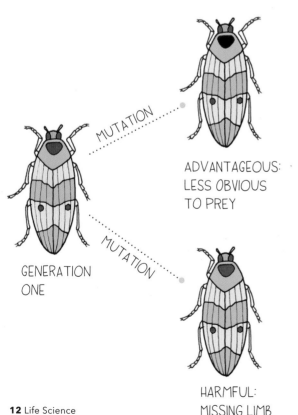

MUTATION

ADVANTAGEOUS: LESS OBVIOUS TO PREY

GENERATION ONE

MUTATION

HARMFUL: MISSING LIMB

3. Genetic drift: CHANGES THAT ARE PURELY BY CHANCE AND NOT FAVORING GENES THAT ARE MORE ADVANTAGEOUS FOR SURVIVAL. A WEATHER EVENT, ACCIDENT, OR HUMAN-CAUSED DEATH (NON-NATURAL PREDATOR) OF CERTAIN INDIVIDUALS THAT DOES NOT REFLECT THEIR GENETIC STRENGTHS OR WEAKNESSES AS INDICATORS

A WORD ABOUT NATURAL SELECTION BEFORE COVERING IT IN ITS ABBREVIATED ENTIRETY. WE HUMANS HAVE A LONG HISTORY OF USING EVOLUTION AS AN ARGUMENT TO PERPETRATE JUDGMENT, HATE, AND VIOLENCE UPON OTHER HUMANS AS WELL AS THE NATURAL WORLD. "SURVIVAL OF THE FITTEST" HAS TURNED INTO A PHRASE USED TO DISCRIMINATE.

NATURAL SELECTION AND ALL OTHER MECHANISMS OF EVOLUTION FUNCTION WITHOUT A PLAN OR END GOAL OTHER THAN SURVIVAL OF SPECIES OVERTIME. EVOLUTION ITSELF DOES NOT HAVE A BIASED STAKE IN WHO EVOLVES AND WHO BECOMES EXTINCT.

FITTEST DOES NOT REFER TO OUR SOCIETAL NOTION OF FIT. IT IS NOT DESCRIBING ONE'S STRENGTH OR SPEED OR INTELLECT. RATHER, IT REFERS TO THE ABILITY OF GENES TO SURVIVE AND ADAPT IN OFFSPRING. NATURAL SELECTION IS SIMPLY DESCRIBING A PROCESS OF CHANGE OVER TIME.

Evolution Pt. II
Natural selection

4. Natural selection: THE MOST WIDELY KNOWN METHOD OF EVOLUTION, NATURAL SELECTION IS RESPONSIBLE FOR MUCH OF THE LARGEST PATTERNS AND TRENDS OF THE EARTH'S ORGANISMS OVER THE PAST 3.8 BILLION YEARS SINCE THE FIRST SINGLE-CELL LIFE APPEARED.

Evolution Pt. III
Natural selection

NATURAL SELECTION REQUIRES AN INITIAL CONDITION OF GENETIC DIVERSITY OR TRAIT VARIATION (SOME BEETLES IN THE POPULATION HAVE A YELLOW HEAD AND SOME HAVE A GREEN HEAD), DIFFERENTIAL REPRODUCTION (NOT ALL INDIVIDUALS CAN PERFECTLY REPRODUCE UNLIMITEDLY—THE YELLOW-HEADED BEETLE MAY BE MORE LIKELY TO BE EATEN BY BIRDS BECAUSE IT IS MORE CONSPICUOUSLY COLORED), AND, FINALLY, THAT TRAITS ARE PASSED ON TO THE NEXT GENERATION (THE YELLOW-HEADED BEETLE IS LESS LIKELY TO SURVIVE TO PASS ALONG THAT COLORATION TRAIT, AND THEREFORE IT BECOMES LESS COMMON IN THE GENE POOL AND EVENTUALLY DISAPPEARS).

IN THIS EXAMPLE, BECAUSE THE BRIGHTNESS OF THE YELLOW-HEADED BEETLE ATTRACTS PREDATORS MORE OFTEN, IT IS GENETICALLY ADVANTAGEOUS FOR THE OFFSPRING OF THIS POPULATION TO HAVE FEWER YELLOW-HEADED GENES IN THE POOL FOR A GREATER CHANCE AT SURVIVAL. IN THEORY THIS CONCEPT IS RELATIVELY SIMPLE; HOWEVER, IN THE REAL WORLD, THERE ARE MANY FACTORS THAT COMPLICATE THE PROCESS, SUCH AS MAN-MADE ENVIRONMENTAL CHANGES, LEARNED BEHAVIOR, AND SEXUAL SELECTION. SEXUAL SELECTION IS TRICKY IN THAT IT RELIES UPON BEHAVIOR AND TERRITORY NOT NECESSARILY GENETICS THAT WOULD BE MOST FAVORABLE TO THE SURVIVAL OF THE SPECIES. THE YELLOW-HEADED BEETLE THAT IS SO FLASHY MIGHT ATTRACT MORE MATES BUT ALSO MORE PREDATORS IN THE PROCESS.

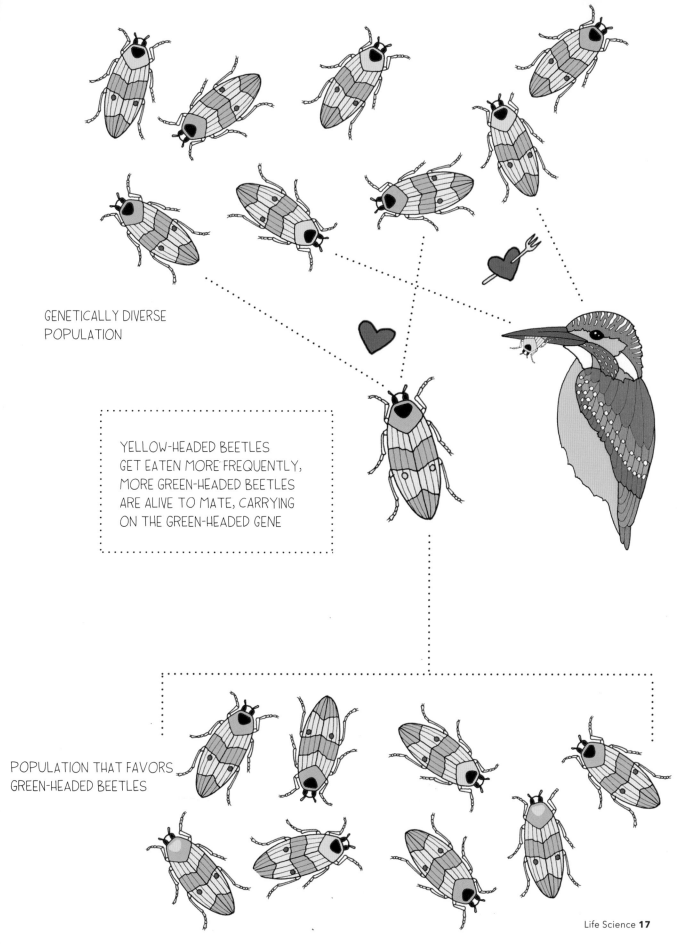

GENETICALLY DIVERSE
POPULATION

YELLOW-HEADED BEETLES
GET EATEN MORE FREQUENTLY,
MORE GREEN-HEADED BEETLES
ARE ALIVE TO MATE, CARRYING
ON THE GREEN-HEADED GENE

POPULATION THAT FAVORS
GREEN-HEADED BEETLES

How Genetically Similar Are You T

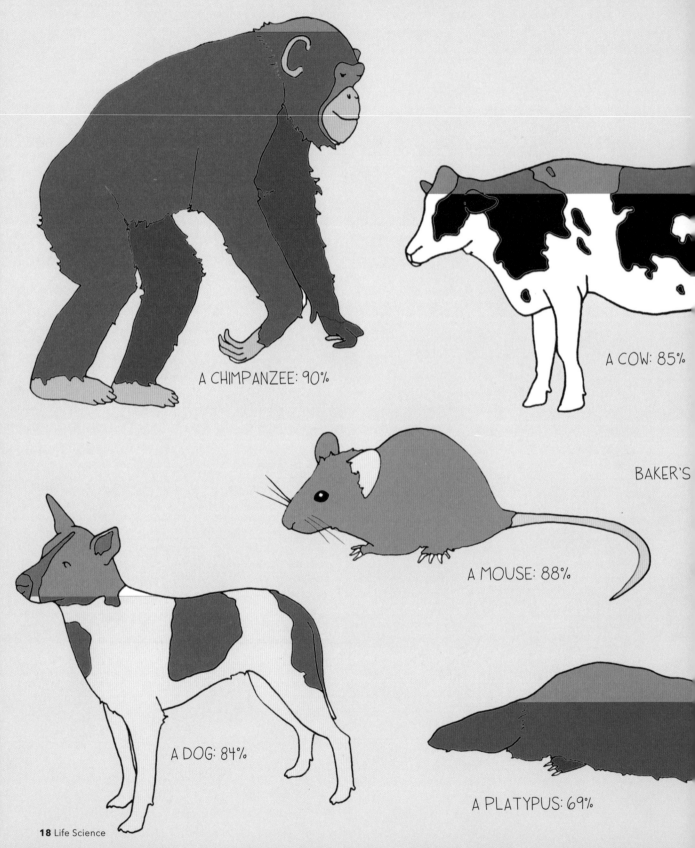

A CHIMPANZEE: 90%

A COW: 85%

A MOUSE: 88%

BAKER'S

A DOG: 84%

A PLATYPUS: 69%

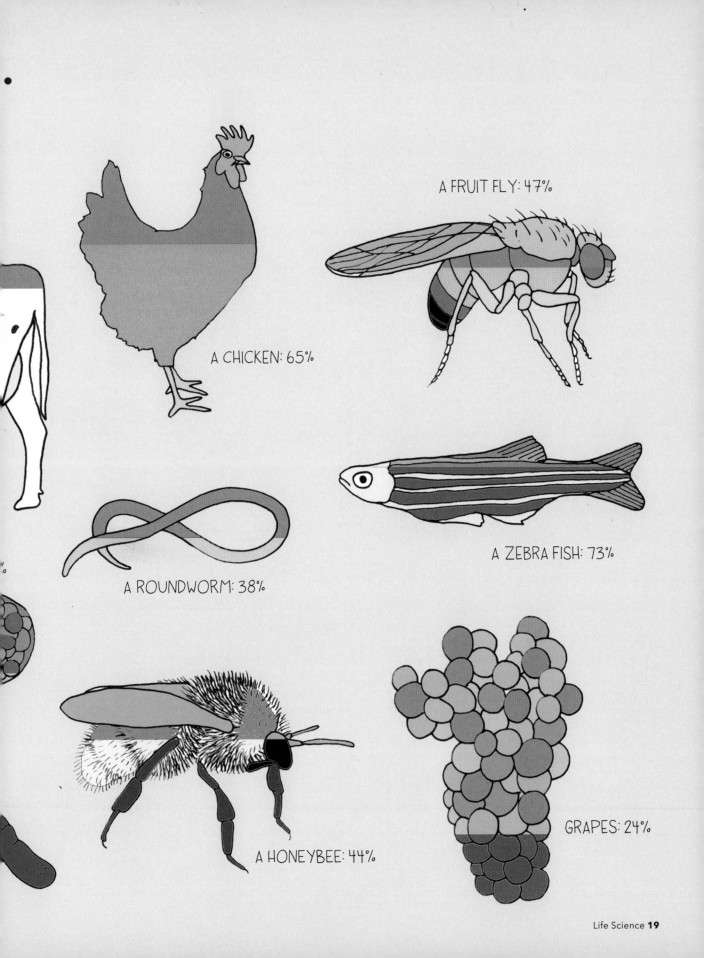

A FRUIT FLY: 47%

A CHICKEN: 65%

A ZEBRA FISH: 73%

A ROUNDWORM: 38%

A HONEYBEE: 44%

GRAPES: 24%

Your Body
By the numbers

Atoms: 7,000,000,000,000,000,000,000,000,000 (7 OCTILLION)
Bacteria: 39,000,000,000,000 (39 TRILLION)
Cells: 37,200,000,000,000 (37.2 TRILLION)
Red blood cells: 24,900,000,000,000 (24.9 TRILLION)
Neurons: 100,000,000,000 (100 BILLION)
Hairs: 5,000,000,000 (5 BILLION)
Length in miles of all blood vessels in an adult body placed end-to-end: 100,000
Days of the longest sneezing fit: 976
Times you blink in a minute: 15-20
DNA chromosome pairs: 23
Years for all bone cells to be replaced: 10

16 OF 32 ADULT TEETH

SWEET TOOTH

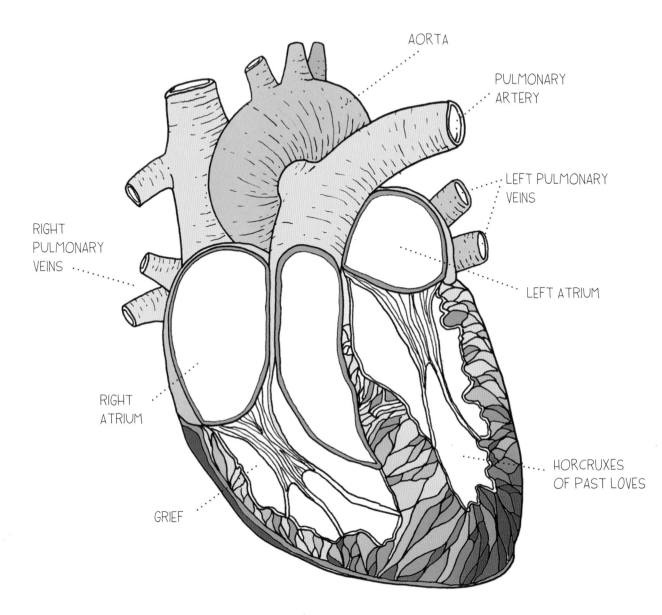

AORTA

PULMONARY ARTERY

LEFT PULMONARY VEINS

RIGHT PULMONARY VEINS

LEFT ATRIUM

RIGHT ATRIUM

HORCRUXES OF PAST LOVES

GRIEF

FIG 1: Anatomy of a human heart

Sperm & Egg
Author **firmly** believes that the egg came before the chicken

50 MICROMETERS (.002 INCHES)

SPERM IS THE SMALLEST CELL IN THE HUMAN BODY

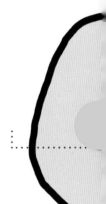

*NOT DRAWN TO SCALE

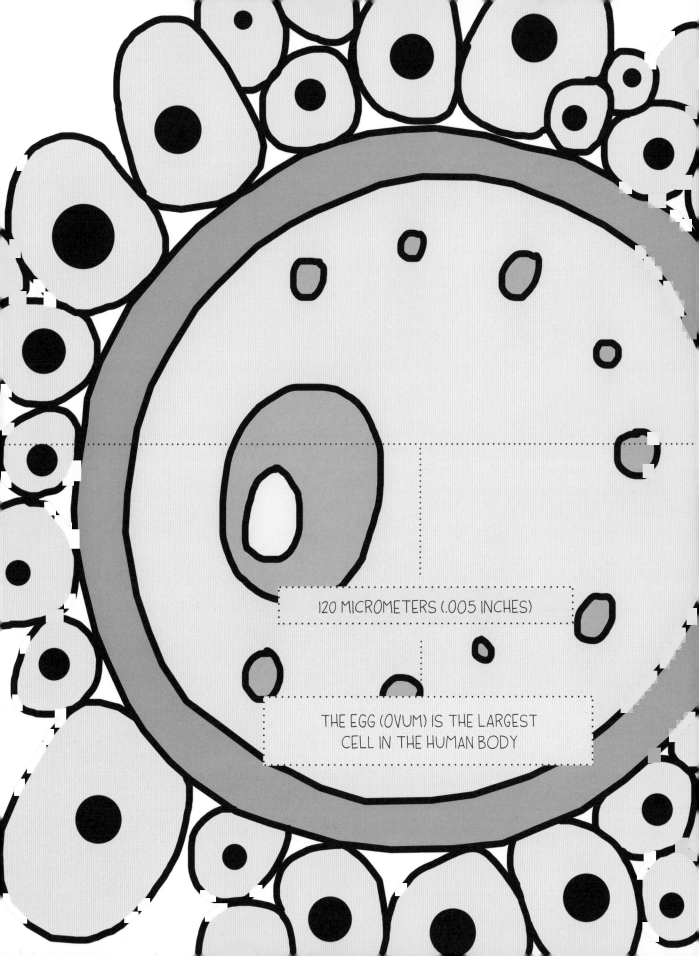

120 MICROMETERS (.005 INCHES)

THE EGG (OVUM) IS THE LARGEST
CELL IN THE HUMAN BODY

Eyes
Are in the head of the beholder

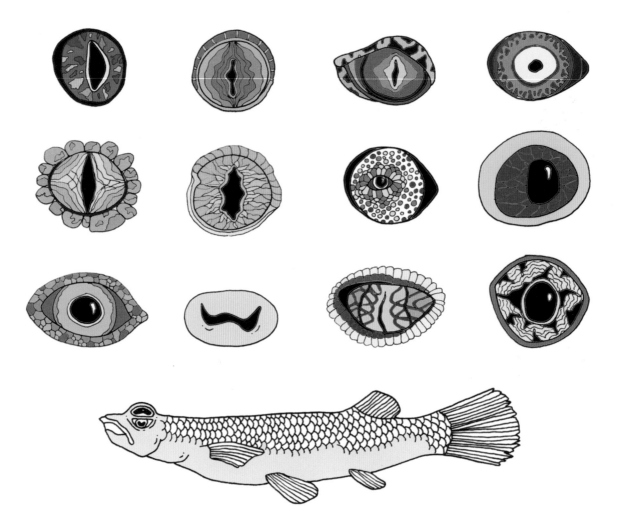

THE FOUR-EYED FISH HAVE DIVIDED EYES WITH TWO PUPILS TO SEE ABOVE AND BELOW THE WATER. THE LENS CHANGES IN THICKNESS TO ACCOUNT FOR THE DIFFERENCE IN REFRACTION OF AIR AND WATER.

ANIMALS ONLY HAVE THE LEVEL OF EYE DEVELOPMENT THAT THEY NEED. IF A SPECIES' SURROUNDINGS CHANGE TO REQUIRE A LESS COMPLEX VISION (CAVE DWELLERS), THEIR EYES WILL EVOLVE TO A LESS COMPLEX, ENERGY-CONSUMPTIVE STRUCTURE.

Eyes are incredibly complex and versatile. The eye can:
- HELP FIND FOOD
- LOCATE MATES
- ALERT TO DANGER
- DETERMINE TIME OF DAY
- DETERMINE DEPTH, COLOR, AND MOVEMENT

PRIMITIVE · COMPLEX

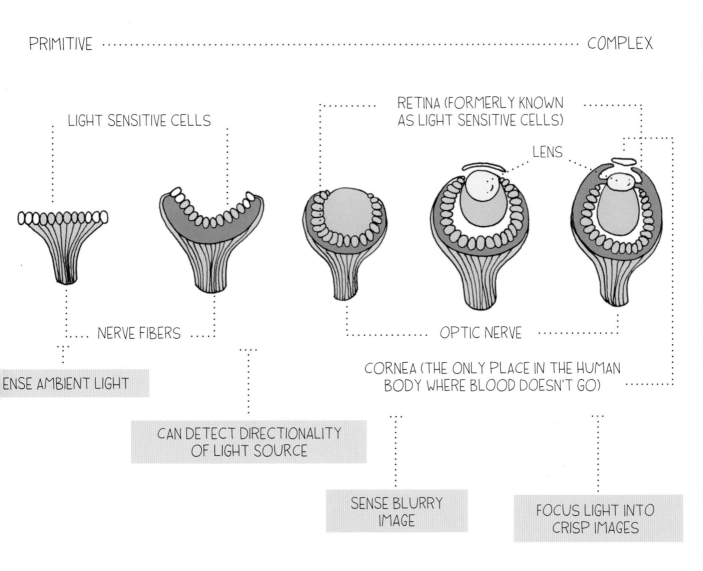

LIGHT SENSITIVE CELLS

RETINA (FORMERLY KNOWN AS LIGHT SENSITIVE CELLS)

LENS

NERVE FIBERS

OPTIC NERVE

ENSE AMBIENT LIGHT

CAN DETECT DIRECTIONALITY OF LIGHT SOURCE

CORNEA (THE ONLY PLACE IN THE HUMAN BODY WHERE BLOOD DOESN'T GO)

SENSE BLURRY IMAGE

FOCUS LIGHT INTO CRISP IMAGES

Hair
Or why your arm hair isn't 3 feet long

THE FINAL LENGTH OF HAIR IS DETERMINED BY
DURATION OF GROWING CYCLES.

Phase 1: ANAGEN (GROWING)
DURING THIS PHASE, HAIR FOLLICLE CELLS ARE DIVIDING
RAPIDLY, ADDING TO THE HAIR SHAFT.
THE LENGTH OF THE ANAGEN PHASE DETERMINES HAIR
LENGTH. THE ANAGEN PHASE FOR HEAD HAIR IS 2 TO 6 YEARS,
WHILE HAIR ELSEWHERE ONLY GROWS FOR 30 TO 45 DAYS
(WHICH IS WHY YOUR ARM HAIR ISN'T 3 FEET LONG).
85 PERCENT OF YOUR HEAD HAIR IS IN THE ANAGEN PHASE AT
ANY GIVEN TIME.

Phase 2: CATAGEN (TRANSITION) THE HAIR STOPS GROWING AND FOLLICLES SHRINK. THIS PHASE IS VERY SHORT, JUST 2 TO 3 WEEKS.

Phase 3: TELOGEN (RESTING) HAIR FOLLICLES TAKE A REST BEFORE STARTING THE CYCLE AGAIN. AT THE END OF THE TELOGEN PHASE, THE HAIR (WHICH NO LONGER RECEIVES NUTRIENTS) FALLS OUT.

The Elusive Science of Sleep
What's up with 8 hours of unconsciousness?

WHY DO WE SLEEP?
THE ANSWER IS SURPRISINGLY
UNCLEAR; HOWEVER, IT MUST
BE AN ESSENTIAL AND UNIQUE
PROCESS IF MOST (IF NOT ALL)
ANIMALS SUCCUMB TO AN
UNCONSCIOUS, PARALYTIC,
AND VULNERABLE STATE
FOR LARGE CHUNKS OF TIME.

HUMANS HAVE EVOLVED TO FOLLOW THE CYCLES
OF THE SEASONS AND SUN (CIRCADIAN RHYTHMS),
THOUGH THAT NATURAL CYCLE HAS BECOME UNNATURAL
SINCE THE ADVENT OF ARTIFICIAL LIGHT. MELATONIN,
THE HORMONE WHOSE RELEASE SIGNALS SLEEPINESS,
IS SUPPRESSED BY THE BLUE LIGHT OF YOUR SCREENS.
 WHILE THE EVOLUTIONARY ROOT OF SLEEP HAS YET
TO BE DETERMINED, WE KNOW THAT DURING SLEEP,
THE BODY STORES MEMORIES, IMPRINTS LEARNING,
PERFORMS CELLULAR REPAIR, REGULATES HORMONES,
AND SUPPORTS IMMUNE FUNCTION.

Sleep process in the brain

Thalamus (1) & Hypothalamus (2)

STIMULATE CEREBRAL CORTEX, WHICH MAINTAINS WAKEFULNESS AND COMPLEX BRAIN FUNCTIONS

Suprachiasmatic Nucleus (4)

LOCATED IN THE HYPOTHALAMUS, THIS GROUP OF CELLS RUN THE INTERNAL BIOLOGICAL CLOCK BASED ON LIGHT SIGNALS FROM THE OPTIC NERVE

Orexin Neurons (5)

A.K.A. THE NEUROTRANSMITTER HYPOCRETIN, STIMULATE AROUSAL CENTERS, KEEPING THE BRAIN AWAKE

Ventrolateral Preoptic Area (3)

RELEASES NEUROTRANSMITTERS THAT INHIBIT SIGNALS FROM THE AROUSAL CENTERS, USHERING IN SLEEPINESS

Tuberomammillary Nucleus (6)

AN AROUSAL CENTER THAT RELEASES THE NEUROTRANSMITTER HISTAMINE (HENCE WHY ANTI-ALLERGY MEDICATIONS A.K.A. ANTI-HISTAMINES CAN INDUCE DROWSINESS....)

THIS POWERHOUSE BRAIN CENTER IS ALSO RESPONSIBLE FOR SLEEP/WAKE CYCLES, HORMONE REGULATION, YOUR INTERNAL THERMOSTAT, AND KEEPING THE BODY ASLEEP THROUGH THE NIGHT

Playing Dead
How we learned to dream

ANIMALS PLAY DEAD TO SEEM UNAPPEALING AS PREY. TONIC IMMOBILITY (OR DEATH FEIGNING) HAS EVOLVED INTO HUMAN AND ANIMAL DREAMS (REM SLEEP STATES).

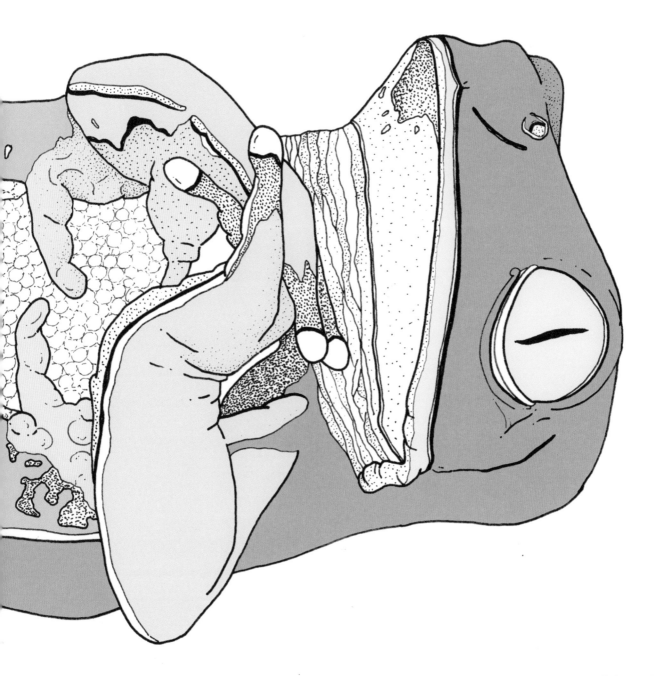

Animal Instincts
Our former selves trying to protect our current selves

DEPRESSION

ANXIETY

TRAUMA

OCD

FEAR

INSOMNIA

WE, LIKE MUCH OF THE ANIMAL KINGDOM, PARTICULARLY MAMMALS, EVOLVED TO PROTECT OURSELVES AND OUR YOUNG FROM HARM BY ANY MEANS NECESSARY. MANY OF THE MOST COMMON MENTAL ILLNESSES EXHIBITED BY HUMANS (AND ANIMALS) ARE THOSE WELL-INTENTIONED IMPULSES GONE AWRY. THE NEED FOR A CLEAN SPACE OR BODY TO AVOID HARMFUL GERMS, SAFELY RAISE OFFSPRING OR TO WIN A MATE CAN BECOME MALADAPTED TO MANIFEST AS OCD.

FEAR AND HIGH-ALERT MODE TO REMAIN VIGILANT IN CASE OF A NEARBY PREDATOR TRANSFORMS INTO ANXIETY AND PARANOIA WHEN IN A SAFER (IN WAYS) ENVIRONMENT THAN THE ONE FROM WHICH HUMANS EVOLVED.

SLEEPING IS THE MOST VULNERABLE ACTIVITY ANIMALS PARTAKE IN, REMAINING UNCONSCIOUS, IMMOBILE, AND PHYSICALLY PARALYZED FOR HOURS AT A TIME. WHEN OUR MINDS DON'T LET OUR BODIES REST, THIS VIGILANCE AT NIGHT CAN CAUSE INSOMNIA.

TRAUMA CAN RESULT IN ALL SORTS OF MANIFESTATIONS INCLUDING TRIGGERING THE ONSET OF MANY OTHER MENTAL ILLNESSES. OUR BODIES, IN REACTION TO TRAUMA, ENTER FIGHT, FLIGHT, OR FREEZE MODE WHEN THEY ARE SENT INTO OVERDRIVE TO PROTECT OURSELVES. IN THIS OVERACTIVE STATE, WE FIGHT, FLEE, OR FREEZE, SOMETIMES MUCH BEYOND THE TRAUMATIC EVENT OR ENVIRONMENT. AN OVERACTIVE SYMPATHETIC NERVOUS SYSTEM CAN LEAD TO A WIDE RANGE OF CHRONIC MENTAL AND PHYSICAL CONDITIONS.

ADDICTION CAN FORM WHEN THE BRAIN HAS TOO-AMPLE INPUT OF A REWARDING SUBSTANCE OR ACTIVITY.

DEPRESSION CAN SERVE IN THE ANIMAL KINGDOM AS A MARKER OF HIERARCHICAL SUBMISSION OR AS A TOOL OF ENERGY CONSERVATION.

THERE IS, AT THE VERY LEAST, SOMETHING COMFORTING ABOUT THE STRONG POSSIBILITY THAT OUR HUMAN STRUGGLES STEM FROM OUR ANIMALISTIC SELVES TRYING THEIR DAMNDEST TO PROTECT US.

Senses
How we know the world around us

THE SENSES COLLECT DATA FROM THE WORLD AROUND US. DIFFERENT SPECIES HAVE EVOLVED TO MORE EFFICIENTLY COLLECT INFORMATION THAT IS MOST RELEVANT AND ADVANTAGEOUS FOR SURVIVAL IN THEIR ENVIRONMENT. THE SENSE RECEPTORS RELAY SPECIFIC SETS OF INFORMATION, SUCH AS SENSING OUTSIDE TEMPERATURE, THE SIGHT OF POTENTIAL PREDATORS APPROACHING, OR WHETHER THAT SCAVENGED MEAT IS ROTTING. THESE INPUTS ARE THEN INTERPRETED BY SPECIFIC REGIONS OF THE BRAIN AND MAY RESULT IN ACTIONS, LIKE MOVING AWAY FROM THE CAUSE OF THE PAIN OR TOWARD A FOOD SOURCE.

CERTAIN ANIMALS HAVE COMPLETELY DIFFERENT SENSE ORGANS THAN HUMANS (E.G., SNAKES THAT CAN "SEE" INFRARED OR RADIANT HEAT USING A SPECIAL PIT ORGAN IN THEIR HEADS). SOME ANIMALS USE THE SAME ORGANS IN DIFFERENT WAYS, SUCH AS KEEN NIGHT VISION FOR NOCTURNAL HUNTERS.

ECHOLOCATION IS A HIGHLY ACCURATE INTERPRETATION OF REFLECTED SOUNDS TO DETECT SURROUNDING SPACE AND FOOD SOURCES. BATS AND CETACEANS (DOLPHINS, WHALES, AND PORPOISES) USE ECHOLOCATION, AND HUMANS WHO ARE BLIND FROM A YOUNG AGE ARE OFTEN ABLE TO USE THE TECHNIQUE TO ORIENT THEMSELVES. THE ALREADY BIZARRE PLATYPUS IS EQUIPPED WITH ANOTHER INTERESTING ATTRIBUTE: ELECTRORECEPTION, THE ABILITY TO DETECT ELECTRIC FIELDS. IT USES THIS IN TANDEM WITH MECHANORECEPTION (THE ABILITY TO DETECT CHANGES IN TOUCH, SOUND, OR PRESSURE) TO FIND PREY IN WATER.

VIBRATION

TASTE

BALANCE

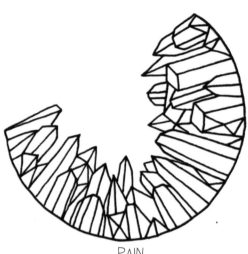

PAIN

TOUCH

TEMPERATURE

GRAVITY

SIGHT

Synesthesia
When a pancake tastes like the number 12

SOMETIMES INPUT FROM OUR SENSES CROSSES PATHS AS IT'S BEING PROCESSED IN OUR BRAINS, PRODUCING A SENSORY MIX-UP CALLED SYNESTHESIA ("TOGETHER SENSATION" IN GREEK). ANY COMBINATION OF SENSES CAN FORM AN EXPERIENCE OF SYNESTHESIA, FROM NUMBERS AND SOUNDS HAVING COLORS (E.G., A FOUR IS ALWAYS CHARTREUSE OR A CAR HORN IS ALWAYS PERIWINKLE), TO CERTAIN WORDS TRIGGERING TASTE SENSATIONS ("CHAIR," WHEN SPOKEN, TASTES LIKE SYRUP) OR "SEEING" TIME LIKE A VISUAL MAP OF PAST MONTHS, DAYS, OR YEARS.

UNLIKE MEMORIES OR SOCIETAL ASSOCIATIONS WE ALL FORM WITH UNCROSSED SENSES (LIKE A FIRE ALARM SOUND REGISTERING AS RED, OR THE WORD "PANCAKE" ELICITING A TASTE MEMORY OF PANCAKES), A SYNESTHETE'S EXPERIENCE OF A CERTAIN SENSATION IS UNIQUE, PERSISTENT, AND REFLEXIVE. THAT CHARTREUSE NUMBER 4 WILL STILL BE CHARTREUSE 10 YEARS LATER.

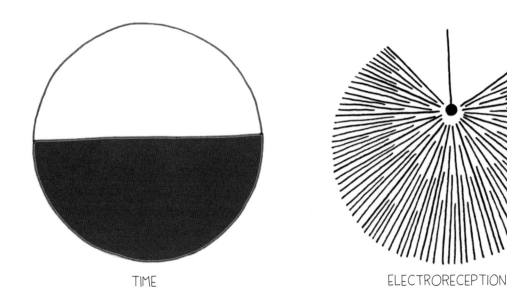

TIME

ELECTRORECEPTION

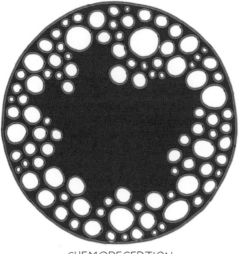

CHEMORECEPTION

SMELL

HEARING

ECHOLOCATION

MAGNETORECEPTION

INFRARED

The Texture of Sounds
Visualizing auditory landscapes

THE PAD OF A DOG
ACROSS CARPET

GARGLING

THE QUIET, STEADY LAP OF A
LAKESHORE AT NIGHT

THE SWISH OF TALL GRASS

WAKING UP BUT STAYING PUT

SOUNDS THAT ARE STEADY AND CONSISTENT, SUCH AS A RUSHING RIVER, A WINDY DAY, OR A CRACKLING FIRE ARE KNOWN AS AUDITORY TEXTURES. WE HAVE EVOLVED TO INTIMATELY AND NECESSARILY KNOW THEM AND EASILY RECOGNIZE THEM. OUR NEURONS CAN READILY IDENTIFY FAMILIAR NATURAL AUDITORY STIMULI (FROM THE INDEX OF HEARD-THIS-BEFORE SOUNDS), WHICH CAN INCLUDE HUMAN SPEECH IN A FAMILIAR LANGUAGE. EVEN IF THESE SOUNDSCAPES ARE CHANGED BY A COMMON FACTOR (THAT RUSHING RIVER SOUND IS NOW FASTER OR AT A HIGHER PITCH), WE CAN STILL RECOGNIZE IT AS FAMILIAR.

Sound

And our delicate inner ear hairs

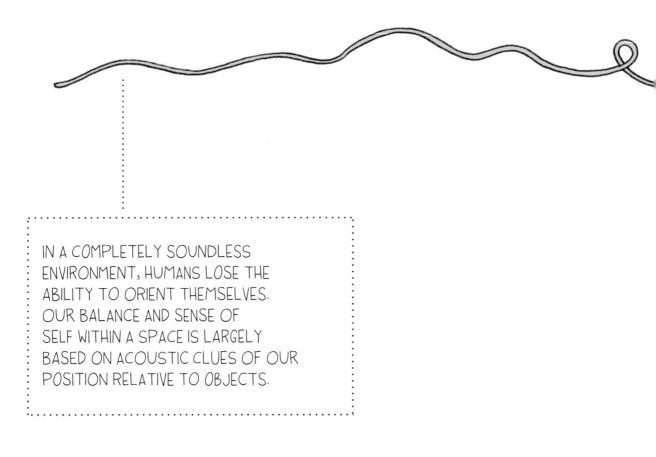

IN A COMPLETELY SOUNDLESS
ENVIRONMENT, HUMANS LOSE THE
ABILITY TO ORIENT THEMSELVES.
OUR BALANCE AND SENSE OF
SELF WITHIN A SPACE IS LARGELY
BASED ON ACOUSTIC CLUES OF OUR
POSITION RELATIVE TO OBJECTS.

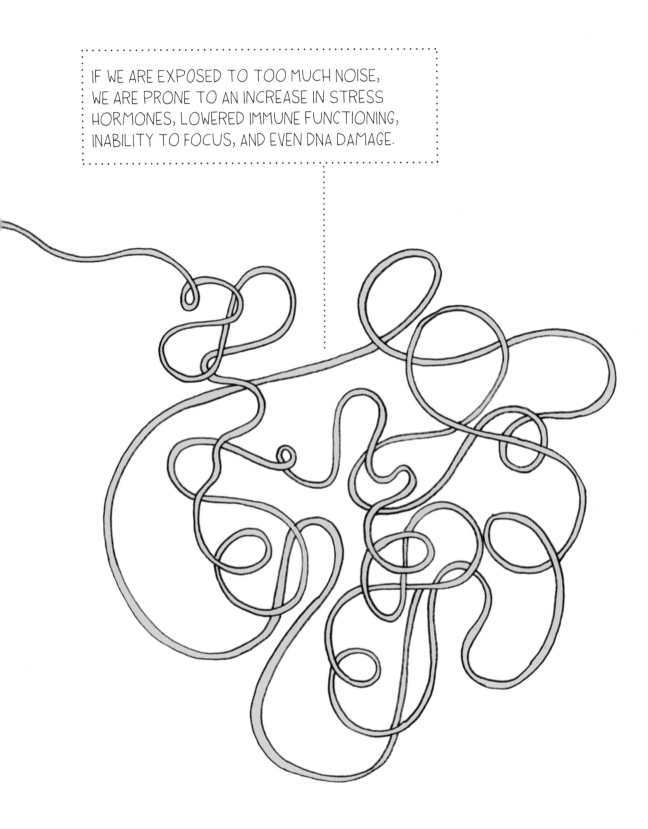

IF WE ARE EXPOSED TO TOO MUCH NOISE,
WE ARE PRONE TO AN INCREASE IN STRESS
HORMONES, LOWERED IMMUNE FUNCTIONING,
INABILITY TO FOCUS, AND EVEN DNA DAMAGE.

Animal Collectives
A selected list

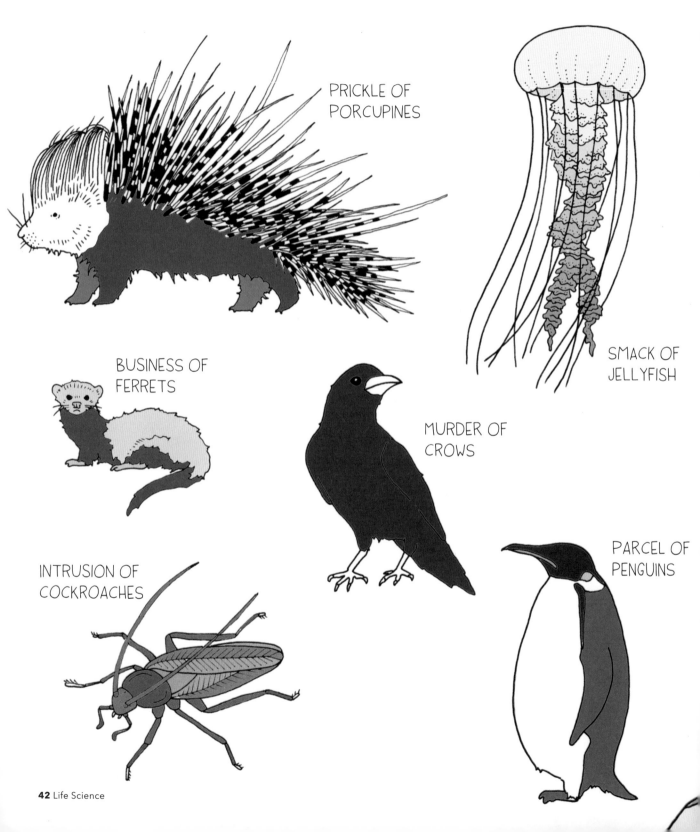

PRICKLE OF PORCUPINES

SMACK OF JELLYFISH

BUSINESS OF FERRETS

MURDER OF CROWS

PARCEL OF PENGUINS

INTRUSION OF COCKROACHES

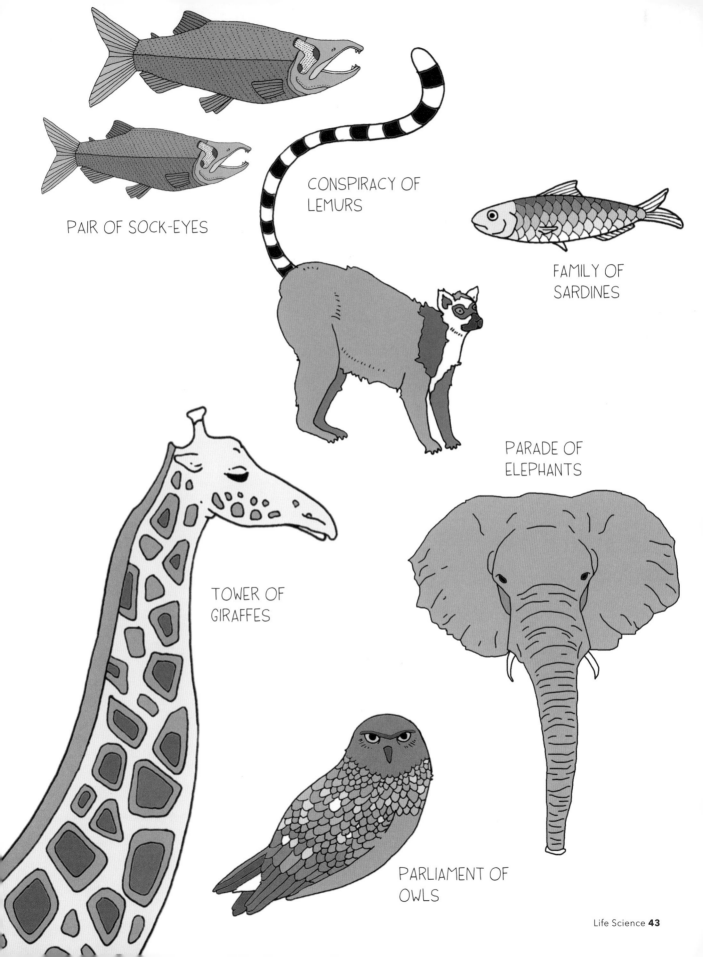

PAIR OF SOCK-EYES

CONSPIRACY OF
LEMURS

FAMILY OF
SARDINES

PARADE OF
ELEPHANTS

TOWER OF
GIRAFFES

PARLIAMENT OF
OWLS

A Tribute to Some of the Creatures Humans Have Killed

By sending them into outer space—or trying to

FRUIT FLIES
MICE
TSYGAN & DEZIK (DOGS)
LAIKA (DOG)
GORDO (SQUIRREL MONKEY)
MARFUSHA (RABBIT)
TREE FROGS
HECTOR (RAT)
HAM (CHIMP)
GUINEA PIG
FELICETTE (CAT)
PARASITIC WASPS
FLOUR BEETLES
AMOEBAE
MONKEYS (MACAQUE)
FUNGI
TORTOISE
BONNY (MACAQUE)
BULLFROGS
NEMATODES
MUMMICHOG FISH
ARABELLA & ANITA (GARDEN SPIDERS)
SALLY, AMY, & MOE (BLACK MICE)
STICK BUGS
NEWTS
MADAGASCAR HISSING COCKROACHES
CHICKEN EGGS
BRINE SHRIMP
JAPANESE TREE FROGS
CRICKETS
SNAILS
CARP
OYSTER TOADFISH
SEA URCHINS
JELLYFISH
SILKWORMS
CARPENTER BEES
HARVESTER ANTS
TARDIGRADES*
SCORPIONS
GECKOS

*THEY'RE PROBABLY STILL THERE
DUE TO THEIR NEAR INDISTRUCTIBILITY.

1973: TWO GARDEN SPIDERS WERE SENT UP TO TEST WEB SPINNING.

1957: LAIKA, THE BELOVED RUSSIAN SPACE DOG, WAS THE FIRST ANIMAL TO ORBIT EARTH. SHE WAS A STRAY FROM THE STREETS.

1985: TEN NEWTS WERE SHOT INTO SPACE WITH PARTIALLY AMPUTATED FRONT LEGS TO TEST REGENERATION IN OUTER SPACE.

1970: TWO BULLFROGS WERE SENT TO TEST MOTION SICKNESS. MANY MORE FROGS HAVE BEEN SENT SINCE THEN BECAUSE THEIR INTERNAL SYSTEM OF BALANCE IS SIMILAR TO HUMANS.

1949: ALBERT I, II, III, AND IV, RHESUS MONKEYS WHO WERE THE FIRST PRIMATES IN SPACE.

1947: FRUIT FLIES WERE THE FIRST VOYAGERS IN SPACE.

2012: MEDAKA FISH WERE SENT UP TO SHOW THE EFFECTS OF MICROGRAVITY IN A SHORT PERIOD OF TIME. THESE MINI ASTRONAUTS PROVIDE A UNIQUE GLANCE (REALLY) INTO BODILY EFFECTS BECAUSE THEY'RE SEE-THROUGH.

THE FISH QUICKLY LOST THE ABILITY TO REGENERATE BONE. THEY ALSO DISPLAYED STRANGE BEHAVIOR SUCH AS SWIMMING IN CIRCLES (DUE TO LOSS OF SPATIAL ORIENTATION).

Ants
Most certainly more organized than humans

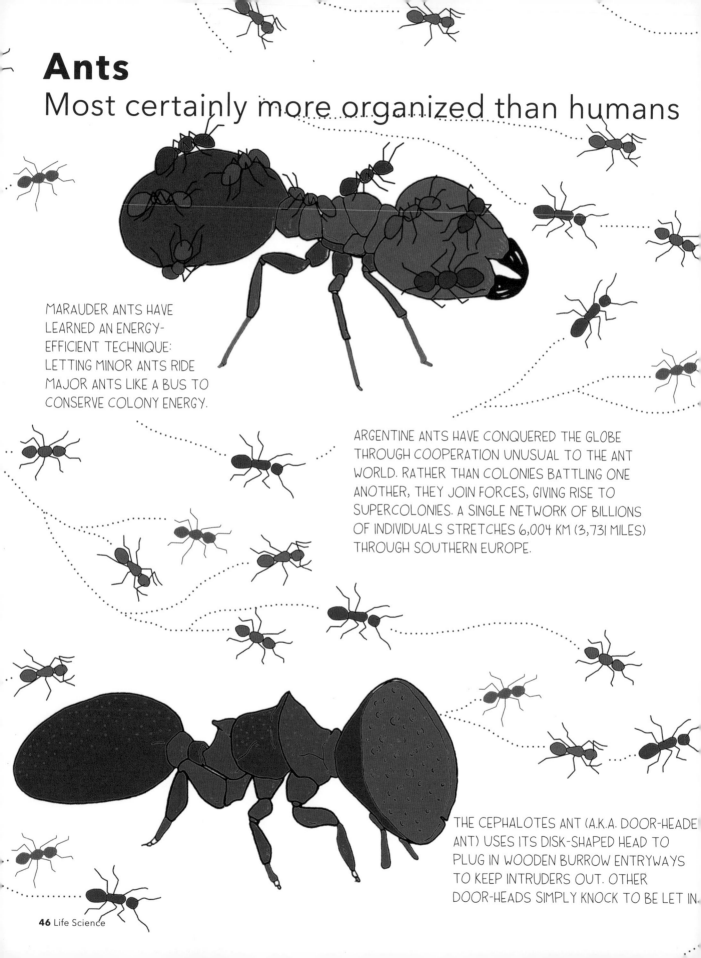

MARAUDER ANTS HAVE LEARNED AN ENERGY-EFFICIENT TECHNIQUE: LETTING MINOR ANTS RIDE MAJOR ANTS LIKE A BUS TO CONSERVE COLONY ENERGY.

ARGENTINE ANTS HAVE CONQUERED THE GLOBE THROUGH COOPERATION UNUSUAL TO THE ANT WORLD. RATHER THAN COLONIES BATTLING ONE ANOTHER, THEY JOIN FORCES, GIVING RISE TO SUPERCOLONIES. A SINGLE NETWORK OF BILLIONS OF INDIVIDUALS STRETCHES 6,004 KM (3,731 MILES) THROUGH SOUTHERN EUROPE.

THE CEPHALOTES ANT (A.K.A. DOOR-HEADED ANT) USES ITS DISK-SHAPED HEAD TO PLUG IN WOODEN BURROW ENTRYWAYS TO KEEP INTRUDERS OUT. OTHER DOOR-HEADS SIMPLY KNOCK TO BE LET IN.

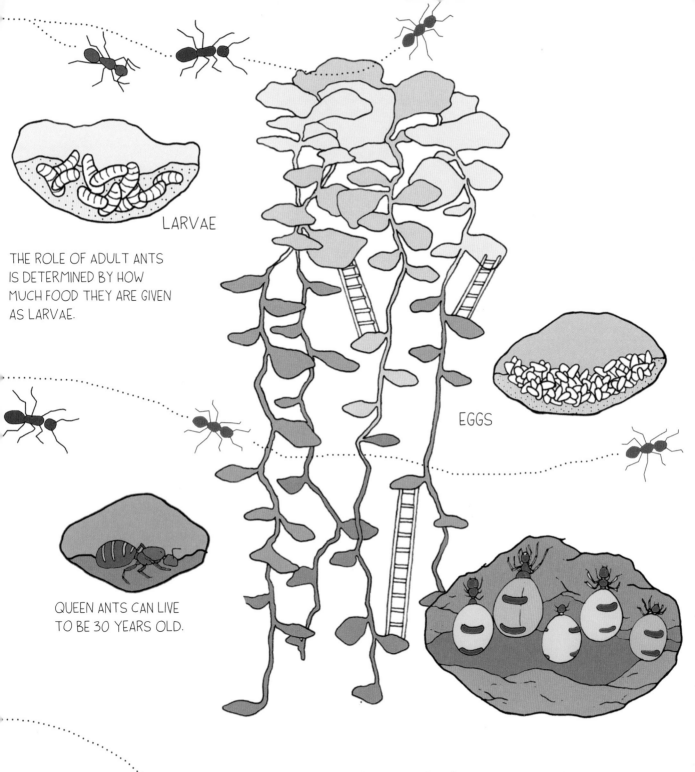

LARVAE

THE ROLE OF ADULT ANTS IS DETERMINED BY HOW MUCH FOOD THEY ARE GIVEN AS LARVAE.

EGGS

QUEEN ANTS CAN LIVE TO BE 30 YEARS OLD.

HONEYPOT ANTS USE SOME COLONY MEMBERS AS LIVING PANTRIES. THE PLERERGATE CASTE GORGE THEMSELVES, STORING LIQUID NUTRIENTS IN THEIR ENGORGED ABDOMENS. THEY HANG FROM CHAMBER CEILINGS UNTIL THE FOOD IS NEEDED, AT WHICH TIME THEY SELF-SACRIFICE OR REGURGITATE THE LIQUID FOR OTHERS.

Blood Flukes

A deadly parasite but a pretty cute couple.

BLOOD FLUKES HAVE THE ABILITY TO REGENERATE THANKS TO THEIR HIGHLY ADAPTABLE STEM CELLS (CALLED NEOBLASTS) WHICH TRAVEL TO ANY DAMAGED AREAS AND QUICKLY DIVIDE, REGENERATING ANY TYPE OF TISSUE. THIS SELF-REPAIRING SYSTEM IS IN PART WHAT ALLOWS THEM TO LIVE FOR DECADES IN A HOST.

BLOOD FLUKES SPEND YEARS IN MONOGAMOUS PAIRS.
THE FEMALE FLUKE RESTS IN THE MALE'S CANOE-LIKE
BODY. THEY CAN REMAIN IN PAIRS FOR DECADES.

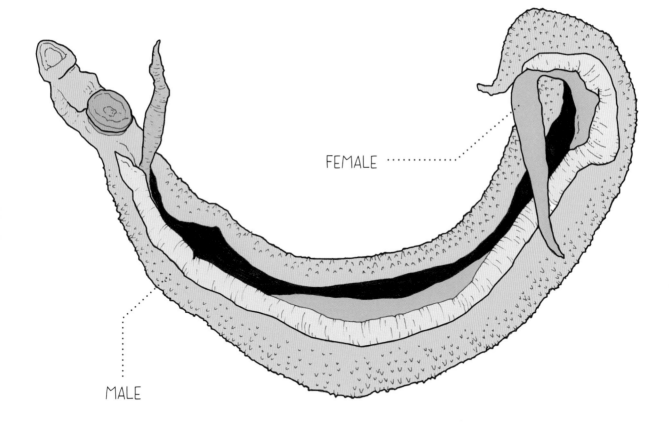

FEMALE

MALE

Building a Bower
Winning a mate by collecting trash

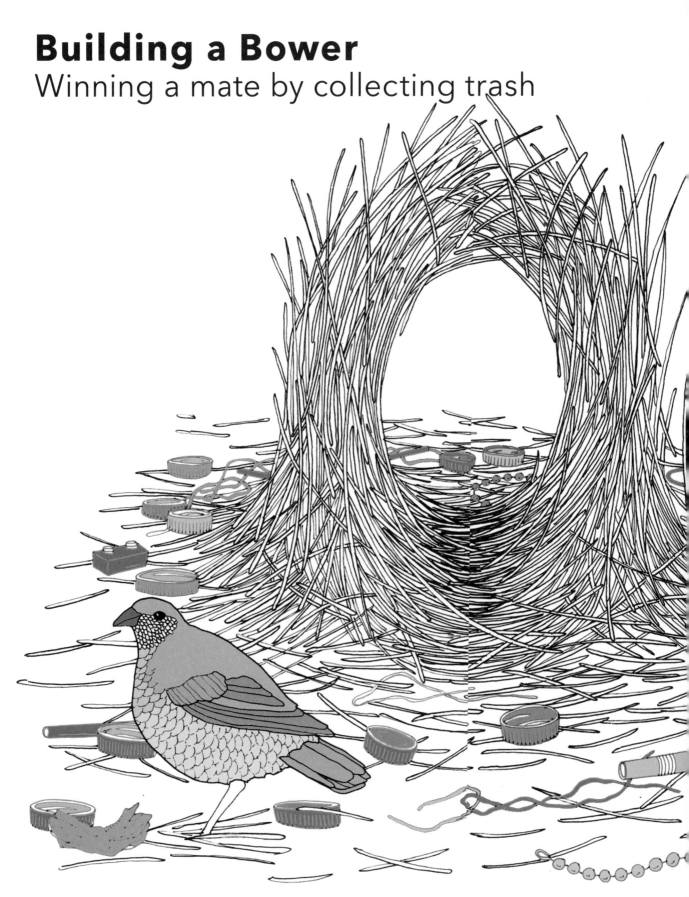

THE GREAT BOWERBIRD (*CHLAMYDERA NUCHALIS*) IS A MASTERFUL BUILDER AND IN SOME CASES, TRICKSTER. MALES HAVE BEEN OBSERVED ARRANGING COLOR-COORDINATED, COLLECTED OBJECTS IN ORDER OF SIZE LEADING UP TO THE ELABORATELY CONSTRUCTED NESTS. THIS ARRANGEMENT CREATES AN OPTICAL ILLUSION TO MAKE THE ELIGIBLE MALE APPEAR LARGER AND MORE IMPRESSIVE. IT IS THE ONLY KNOWN ANIMAL TO EMPLOY OPTICAL ILLUSIONS WITH EXTERNAL OBJECTS FOR MATING.

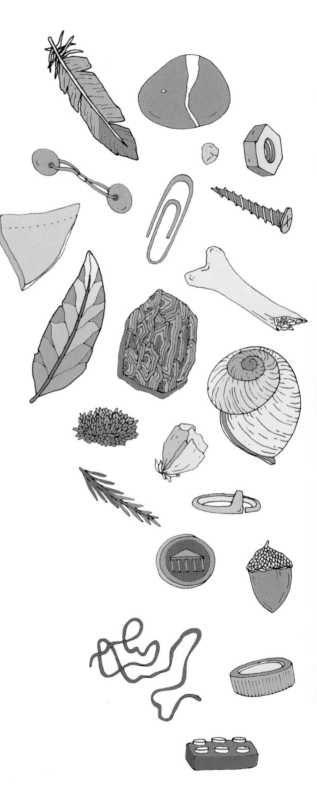

Naked Mole Rats
No modesty, lots of quirks

1. THE MOLE RAT IS THE ONLY COLD-BLOODED MAMMAL. ITS BODY TEMPERATURE ADJUSTS TO MATCH THE AMBIENT TEMPERATURE IN ITS SURROUNDINGS, TIGHTLY PACKED WITH OTHER MOLE RATS UNDERGROUND.

2. THEY ARE NOT AFFECTED BY ACID. SCIENTISTS INJECTED THEM WITH ACID AND THEY DIDN'T EVEN FLINCH. SCIENTISTS SUSPECT THAT IN ADDITION TO THEIR BEING HYPOSENSITIVE TO PAIN, THEIR BODY CHEMISTRY IS ALREADY SO ACIDIC THAT THE INJECTION DIDN'T REGISTER.

3. LONGEST LIVING RODENT AWARD: NAKED MOLE RATS CAN LIVE UP TO 32 YEARS OLD, OWING TO THE PRODUCTION OF A SPECIAL PROTEIN CALLED HSP25, WHICH GETS RID OF DEFECTIVE PROTEINS BEFORE THEY CAN CAUSE DISEASES. THEY ARE ALSO RESISTANT TO CANCER BECAUSE OF A SUGAR THAT PREVENTS CELLS FROM OVERCROWDING AND CLUMPING TO FORM TUMORS.

** HONORABLE MENTION IN THE INCREDIBLE UNDERRATED ANIMAL CLUB IS THE TARDIGRADE, A.K.A. WATER BEAR, A.K.A MOSS PIGLET. THESE ANCIENT TINY ORGANISMS ARE ABUNDANT IN ALMOST EVERY ECOSYSTEM AND ARE VIRTUALLY INDESTRUCTIBLE: THEY CAN SURVIVE IN A DEHYDRATED STATE FOR YEARS, BE PERFECTLY FINE IN VACUOUS OUTER SPACE, AND THRIVE IN EXTREME HEAT AND COLD.

4. WHEN HUNDREDS OF NAKED MOLE RATS PACK TIGHTLY IN SUBTERRANEAN BURROWS, OXYGEN CAN BE SCARCE. MOST MAMMALS CANNOT SURVIVE FOR MORE THAN A COUPLE MINUTES WITH ACCESS TO ONLY A 5 PERCENT OXYGEN SUPPLY. DURING ANOXIA (TOTAL OXYGEN DEPRIVATION), NAKED MOLE RATS CAN LIVE UP TO FIVE HOURS BY ENTERING "SUSPENDED ANIMATION." DURING THIS TIME THEY SWITCH TO A PROCESS USED BY THE PLANT KINGDOM: METABOLIZING ENERGY FROM FRUCTOSE. THEY CAN RECOVER FROM THESE LOW-OXYGEN ENVIRONMENTS WITH NO BRAIN DAMAGE.

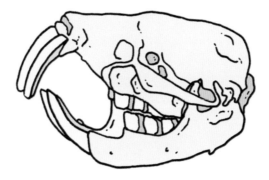

5. UNLIKE MOST RODENTS (AND MAMMALS FOR THAT MATTER), NAKED MOLE RATS ARE ORGANIZED MORE LIKE HIGHLY SOCIAL INSECTS (E.G., BEES AND ANTS) THAN THEIR FURRY BRETHREN. SIXTY TO THREE HUNDRED MEMBERS LIVE IN ONE COLONY WITH A COMPLEX UNDERGROUND CHAMBER SYSTEM. THEY HAVE DESIGNATED COLONY ROLES, WITH ONE DOMINANT, REPRODUCING QUEEN, A FEW FERTILE MALES, AND MANY STERILE WORKERS. IN INSECT COLONIES, IF THE QUEEN DIES, THE WORKERS INTENTIONALLY CREATE A NEW QUEEN THROUGH FEEDING. HOWEVER, IF A NAKED QUEEN MOLE RAT DIES (OR IS REMOVED), SEVERAL FEMALES SUDDENLY BECOME FERTILE AND MUST FIGHT FOR HER POSITION AS THE NEXT QUEEN.

6. THEIR MOUTHS ARE CLOSED BEHIND THEIR TEETH LEST THEY GET A MOUTHFUL OF DIRT AS THEY BURROW.

Owls Of North America
Whoooo are they?

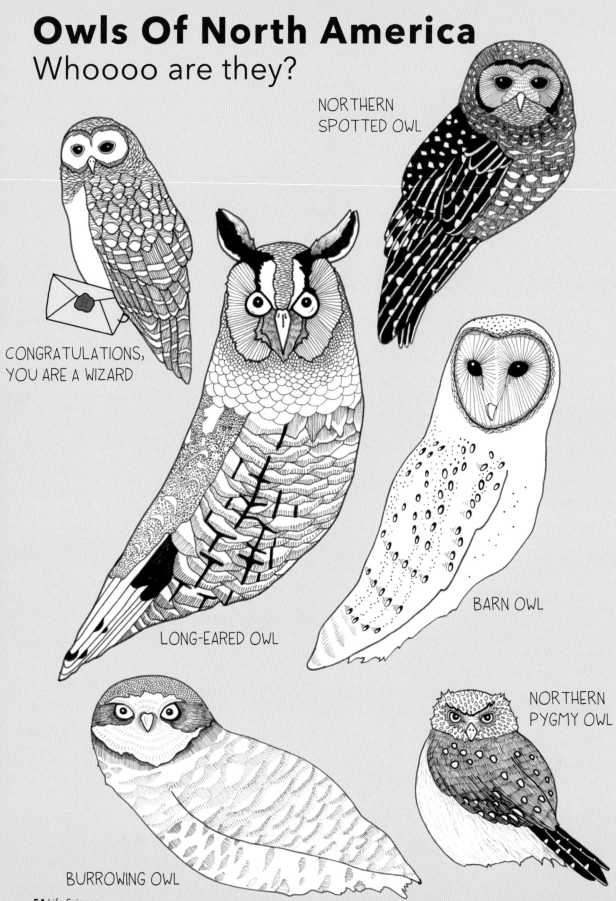

NORTHERN SPOTTED OWL

CONGRATULATIONS, YOU ARE A WIZARD

LONG-EARED OWL

BARN OWL

NORTHERN PYGMY OWL

BURROWING OWL

HUMANS HAVE LONG HAD MAJESTIC AND SUPERSTITIOUS LORE ABOUT OWLS, WHO HUNT ONLY AT NIGHT, STARE INTENSELY WITH BRIGHT YELLOW EYES, FLY SILENTLY, AND EAT THEIR PREY WHOLE. IN MANY NATIVE AMERICAN CULTURES THEY ARE OMINOUS SIGNS OF IMPENDING DEATH, COMPANIONS TO DEATH GODS, OR ABLE TO COMMUNICATE WITH THE DECEASED.

OWLS HAVE HIGHLY DEVELOPED, UNUSUAL EYES, WHICH ARE CONSTRUCTED LIKE TUBES INSTEAD OF SPHERES AND ARE HELD IN PLACE BY BONY STRUCTURES. THIS MEANS OWLS CANNOT ROLL OR MOVE THEIR EYES; THEY MUST MOVE THEIR HEAD TO LOOK ANYWHERE OTHER THAN STRAIGHT AHEAD. LUCKILY, NATURE HAS DESIGNED THEIR HEADS TO SWIVEL 270 DEGREES AROUND. A SPECIAL MECHANISM IN THEIR CIRCULATORY SYSTEM ALLOWS THIS INCREDIBLE RANGE OF MOTION WITHOUT DEPRIVING THEIR BRAINS OF BLOOD FLOW. OWLS ARE ALSO PERMANENTLY FAR-SIGHTED TO AID IN HUNTING SMALL PREY FROM FAR AWAY.

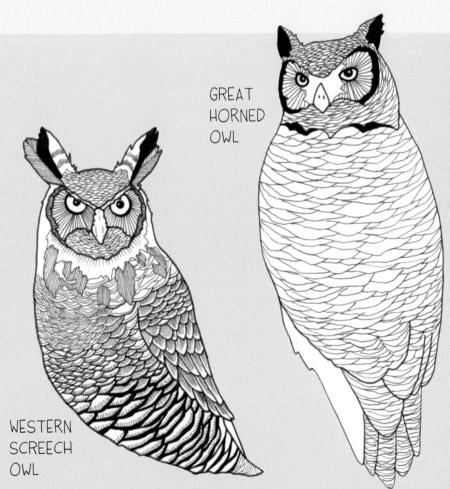

GREAT HORNED OWL

WESTERN SCREECH OWL

Pigeons
They're not so bad

PIGEONS HAVE INCREDIBLE NATURAL GPS SYSTEMS WITH THE ABILITY TO FIND THEIR WAY HOME OVER LONG DISTANCES, EVEN THOUSANDS OF MILES. USED SINCE ANCIENT TIMES, HOMING PIGEONS HAVE SERVED AS MAIL CARRIERS AND WAR MESSENGERS, AND ARE REKNOWN FOR THEIR ABILITY TO DETECT THE SLIGHTEST AMOUNT OF BREAD DROPPED ON THE GROUND.

SCIENTISTS HAVE SOME THEORIES AS TO HOW PIGEONS (AND MANY OTHER MIGRATORY ANIMALS) NAVIGATE:

Magnetoreception: USING THE EARTH'S MAGNETIC FIELD AS AN INTERNAL COMPASS
Olfactory navigation: USING ENVIRONMENTAL ODORS AS A GUIDING MAP
Infrasound waves: USING VERY LOW-FREQUENCY WAVES TO CREATE AN ACOUSTIC MAP
Sun positioning: WHAT IT SOUNDS LIKE

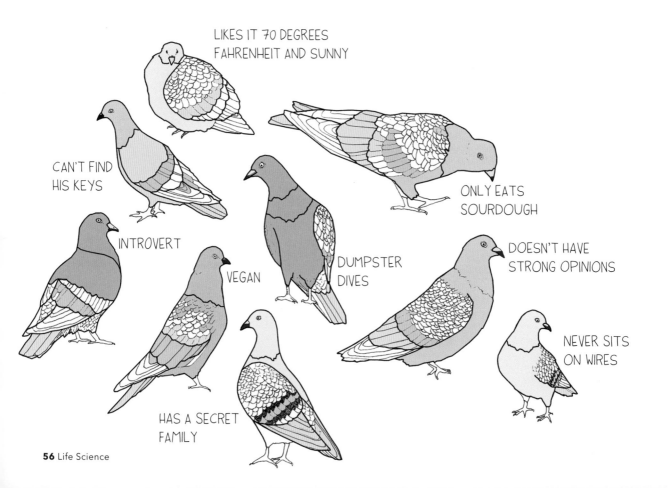

LIKES IT 70 DEGREES FAHRENHEIT AND SUNNY

CAN'T FIND HIS KEYS

ONLY EATS SOURDOUGH

INTROVERT

VEGAN

DUMPSTER DIVES

DOESN'T HAVE STRONG OPINIONS

NEVER SITS ON WIRES

HAS A SECRET FAMILY

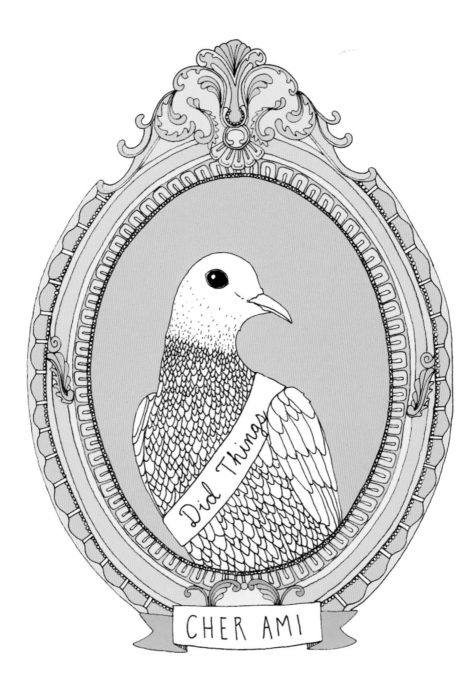

FIG 2: Cher Ami

CHER AMI WAS A HOMING PIGEON WHO SERVED IN WORLD
WAR I. HE FLEW 25 MILES TO DELIVER A MESSAGE THAT
SAVED 194 SOLDIERS, BUT GOT SHOT AND LOST AN EYE AND
A LEG IN THE PROCESS. MEDICS SAVED HIM AND CARVED HIM
A TINY WOODEN LEG.

Notable Teeth
& strange protrusions

THE NARWHAL IS THE ONLY KNOWN CREATURE WITH A STRAIGHT TUSK AND A SPIRALED TOOTH. THE LEFT TOOTH (ALWAYS THE LEFT) BREAKS THROUGH THE LIP AND EXTENDS UP TO 10 FEET LIKE A HORN. ALL MALES HAVE AT LEAST ONE TUSK (ALTHOUGH RARELY THERE ARE DOUBLE-TUSKED NARWHALS) BUT AROUND 15 PERCENT OF FEMALES HAVE A TUSK AS WELL. UNLIKE MOST TEETH, WHICH HAVE A HARD PROTECTIVE LAYER OF ENAMEL COATING THE OUTSIDE, THIS TOOTH IS SOFT ON THE OUTSIDE AND HARD ON THE INSIDE. THE TUSK FUNCTIONS LIKE A SENSORY ORGAN, ABLE TO SENSE CHANGES IN SALINITY, WATER PRESSURE, AND TEMPERATURE. BECAUSE ONLY MALES POSSESS THE TEETH, THE PROTRUSIONS ARE NOT NECESSARY FOR SURVIVAL AND MAY BE RELATED TO MATING BEHAVIOR OR COURTING.

10 FEET

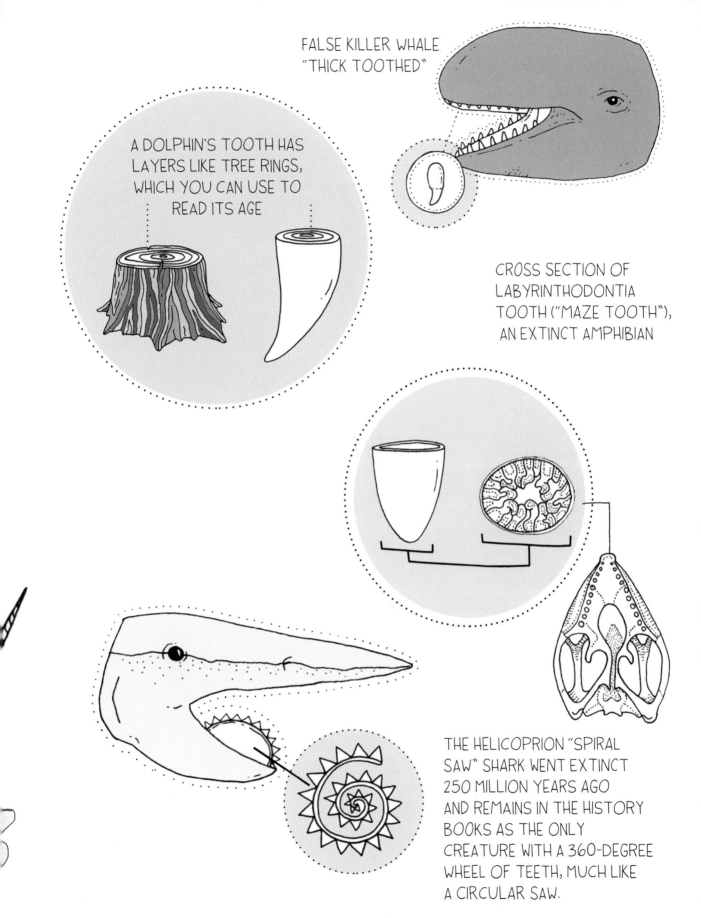

FALSE KILLER WHALE "THICK TOOTHED"

A DOLPHIN'S TOOTH HAS LAYERS LIKE TREE RINGS, WHICH YOU CAN USE TO READ ITS AGE

CROSS SECTION OF LABYRINTHODONTIA TOOTH ("MAZE TOOTH"), AN EXTINCT AMPHIBIAN

THE HELICOPRION "SPIRAL SAW" SHARK WENT EXTINCT 250 MILLION YEARS AGO AND REMAINS IN THE HISTORY BOOKS AS THE ONLY CREATURE WITH A 360-DEGREE WHEEL OF TEETH, MUCH LIKE A CIRCULAR SAW.

Fungi
The destroyers & the creators

BIRD'S NEST

FUNGI ARE HIGHLY ADAPTABLE DECOMPOSERS FOUND IN ALMOST EVERY BIOME.

FUNGI HAVE EVOLVED TO BREAK DOWN SPECIFIC MATERIALS AND CHEMICALS RANGING FROM SIMPLE SUGARS TO ANIMAL HOOVES TO RADIATION. FUNGI SECRETE ENZYMES THAT CONVERT THE RAW MATERIALS INTO AN ENERGY SOURCE WHICH THEN ENRICHES THE SOIL, CONTINUING THE GROWTH AND DECOMPOSITION CYCLE.

TURKEY TAIL

INSTEAD OF FEEDING ON THE ALREADY DEAD, ABOUT 200 SPECIES OF FUNGI USE MORE SINISTER METHODS TO KILL AND EAT NEMATODES, TINY WORMS. THESE NEMATOPHAGEOUS FUNGI TRAP THEIR PREY WITH ADHESIVES OR SNARES, STUN OR IMMOBILIZE THEM WITH POISON, OR INFECT NEMATODE EGGS. THEY THEN EAT THEM ALIVE AT THEIR LEISURE. THIS RELATIONSHIP IS A WIN-WIN FOR THE SURROUNDING ECOSYSTEM, FOR WHICH THE NEMATODE POPULATION IS KEPT IN CHECK.

FLY AGARIC
(A.K.A. TOADSTOOL)

HONEY FUNGUS*

PHOENIX OR LUNG OYSTER

MYCORRHIZAL SYMBIOSIS: MORE THAN 90 PERCENT OF PLANTS HAVE A COLLABORATIVE RELATIONSHIP WITH MYCORRHIZA, A FUNGUS THAT GROWS ON PLANT ROOTS. THE MYCORRHIZAL SYSTEM HAS *EXTREMELY* FINE FILAMENTS, WHICH GIVES IT A MUCH GREATER SURFACE AREA THAN THE PLANTS OWN ROOTS FOR ABSORBING WATER AND NUTRIENTS FROM SURROUNDING SOIL.

FORESTS HAVE ENORMOUS UNDERGROUND NUTRIENT-EXCHANGING NETWORKS.

*THE LARGEST ORGANISM ON EARTH IS A HONEY FUNGUS WITH A 2,400-ACRE NETWORK OF MYCELLIUM (THE UNDERGROUND PART OF THE FUNGUS). IT IS 2,000 YEARS OLD.

Ferns
Introverts of the forest floor

FIG 3: The fiddlehead

FERNS ARE KNOWN FOR BEING
SHY, PREFERRING THE DARK,
QUIET FOREST FLOOR.

FERN FROND VARIATIONS

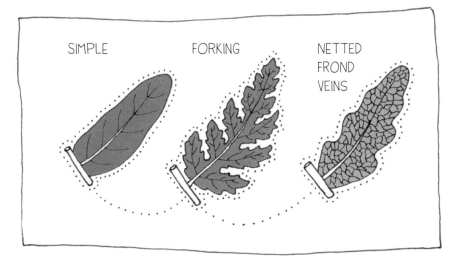

SIMPLE

FORKING

NETTED FROND VEINS

FERN ALLIES

WHISKBROOM

HORSETAIL

CLUBMOSS

QUILLWORT

SPIKEMOSS

Gigantic Beautiful Flowers
That smell like rotting meat

MANY SPECIES OF PLANTS HAVE DEVELOPED AN INGENIOUS STRATEGY TO ATTRACT POLLINATORS WHO HAVE A TASTE (AND SMELL) FOR ROTTING MEAT. THE SCENT MIMICRY OF THESE PLANTS ATTRACTS CARRION BEETLES, FLESH FLIES, MOTHS, AND OTHER INSECTS WHO COME EXPECTING A DECAYING FLESH PARTY. WHILE THEY DON'T GET A SATISFYING MEAL, THEY'RE NOW UNWITTING POLLINATORS FOR THE PLANT. ANIMALS SUCH AS ANTS, SQUIRRELS, AND ELEPHANTS (WHO DON'T ESPECIALLY CARE FOR SMELLY FLESH) ALSO CARRY AWAY SEEDS ON THEIR FEET.

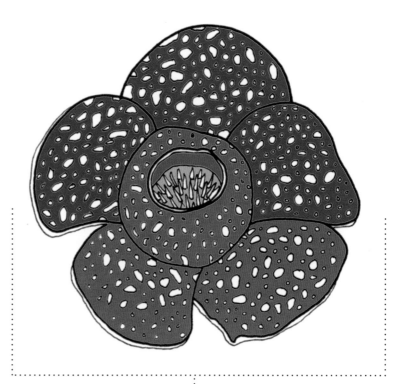

3 FEET ACROSS, WEIGHS 15 TO 25 LBS

Rafflesia Arnoldii
A.K.A. CORPSE LILY

Location: SUMATRA

Most notable trick: PARASITISM. THIS FLOWER (THE LARGEST SINGLE BLOOM ON EARTH) HAS NO ROOT SYSTEM, NO CHLOROPHYLL, AND NO LEAVES OR STEMS. IT GROWS WITHIN THE WOODY STEMS OF A VINE AND GETS ITS WATER AND NUTRIENTS FROM ITS HOST.

12 FEET TALL, WEIGHS UP TO 220 LBS

Amorphophallus Titanum
A.K.A. CORPSE FLOWER, DEVIL'S TONGUE, SNAKE PALM

Location: SUMATRA

Most notable trick: ATTRACTING THE CARCASS-EATING INSECTS THAT WILL POLLINATE THE RARE FLOWER. WHEN THE CORPSE FLOWER BLOOMS, THE SPADIX (THE THICK CENTRAL SPIKE) HEATS UP TO ABOUT 98 DEGREES FAHRENHEIT, HELPING TO SPREAD THE ROTTING MEAT AROMA AND CREATING THE ILLUSION THAT THE PLANT ITSELF IS DECAYING FLESH.

CHEMICAL ANALYSIS OF THE ODORS RELEASED BY THE SPADIX IDENTIFIED THE FOLLOWING SMELLS:

- COOKED ONIONS
- LIMBURGER CHEESE
- GARLIC
- ROTTING FISH
- AMMONIA
- SWEATY SOCKS
- MOTHBALLS
- CHLORASEPTIC SPRAY
- JASMINE
- HYACINTH
- HUMAN FECES

SMALL FRUITS GROW AT THE BASE OF THE FLOWER, ATTRACTING BIRDS THAT EAT AND DISPERSE THE SEEDS.

Viruses
Not quite alive

WHAT IS A VIRUS? IS IT LIVING OR NOT? THIS QUESTION HAS BEEN DEBATED SINCE VIRUSES WERE FIRST DISCOVERED IN 1892. WHILE IT HAS QUALITIES OF A LIVING ORGANISM (GENETIC MATERIAL, THE ABILITY TO REPRODUCE, AND ARE SUBJECT TO THE PROCESS OF NATURAL SELECTION), VIRUSES DO NOT HAVE CELL WALLS, CANNOT TURN FOOD INTO ENERGY, AND REQUIRE A HOST TO SURVIVE AND REPRODUCE.

MANY VIRUSES HAVE THE ABILITY TO CAMOUFLAGE THEMSELVES WITHIN THE HOST BODY TO AVOID BEING DETECTED BY IMMUNE SYSTEM RESPONDERS. THERE ARE MANY WAYS TO HIDE, INCLUDING IMITATION OF HOST CELLS AND FOLDING THEMSELVES INSIDE HOST MEMBRANES.

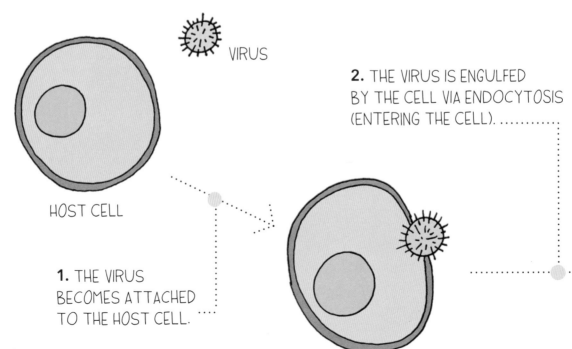

VIRUS

HOST CELL

1. THE VIRUS BECOMES ATTACHED TO THE HOST CELL.

2. THE VIRUS IS ENGULFED BY THE CELL VIA ENDOCYTOSIS (ENTERING THE CELL).

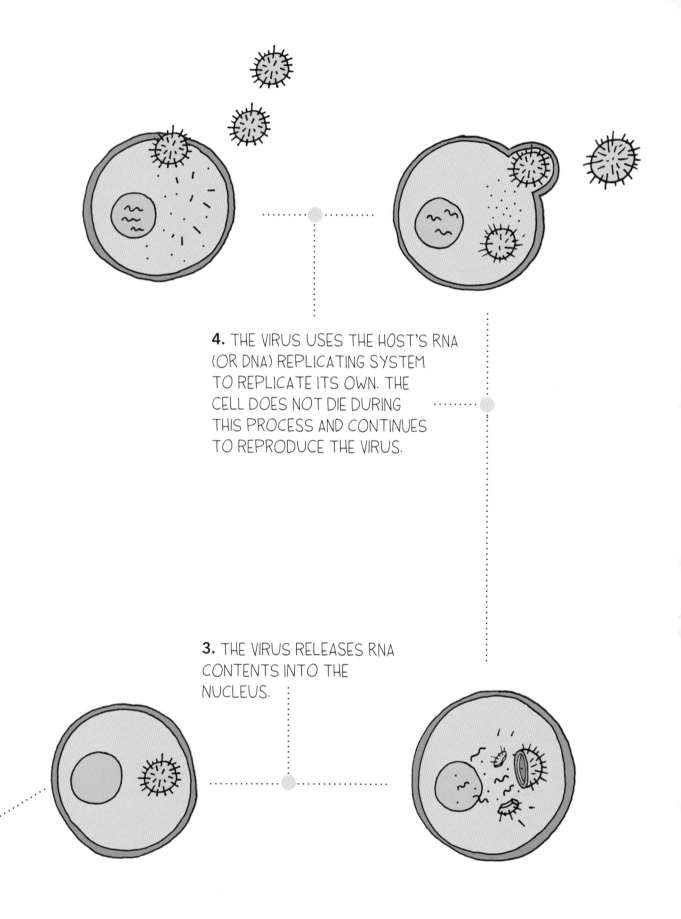

4. THE VIRUS USES THE HOST'S RNA (OR DNA) REPLICATING SYSTEM TO REPLICATE ITS OWN. THE CELL DOES NOT DIE DURING THIS PROCESS AND CONTINUES TO REPRODUCE THE VIRUS.

3. THE VIRUS RELEASES RNA CONTENTS INTO THE NUCLEUS.

Yeasts, Amoebae, Prions, and Rabies
Four weird but possible ways to die

Yeasts: SINGLE-CELLED, EUKARYOTIC MICROORGANISMS THAT HAVE LONG BEEN A FRIENDLY FUNGUS PAL TO HUMANS IN BREAD-MAKING AND BEER-BREWING. HOWEVER, THE DRUG-RESISTANT SPECIES *CANDIDA AURIS* CAN KILL YOU.

Amoebae: A SHAPE-SHIFTING SINGLE CELL EUKARYOTE THAT MORPHS ITS SHAPE TO MOVE. ONE FRESH-WATER- DWELLING SPECIES, *NAEGLERIA FOWLERI*, APTLY NICKNAMED THE "BRAIN-EATING AMOEBA," ENTERS THE BODY THROUGH THE NOSE. SO WHEN YOU'RE SWIMMING IN A LAKE THIS SUMMER, PLUG YOUR NOSE. (THAT'S ACTUAL ADVICE FROM THE CENTERS FOR DISEASE CONTROL, SO DO IT.)

Prions: A FOLDING OF CELL PROTEINS. ALL OF YOUR CELLS HAVE PROTEIN IN THEIR MEMBRANES, AND WHEN AN ORGANISM (MAD COWS IN "MAD COW DISEASE" FOR EXAMPLE) ARE AFFECTED BY PRIONS, A PROTEIN MALFUNCTIONS AND FOLDS, CAUSING A DOMINO EFFECT AMONG THE SURROUNDING PROTEINS. THE ONSET CAN BE GENETIC OR RANDOM. ONE GENETIC MANIFESTATION OF PRION DISEASE IS FATAL FAMILIAL INSOMNIA, IN WHICH THE BODY IS NO LONGER ABLE TO SLEEP, LEADING TO HALLUCINATIONS, DEMENTIA, AND DEATH.

Rabies: A NOTORIOUS VIRUS KNOWN FOR INFECTING RACCOONS, DOGS, AND BATS IS ONE OF THE MORE MYSTERIOUS VIRUSES WHEN IT AFFECTS HUMANS. THE VIRUS IS CONTRACTED AT THE SITE OF A BITE FROM A RABID ANIMAL. THE RABIES CRAWLS (SO CREEPY) UP THE BODY'S NERVES UNTIL IT REACHES THE BRAIN. ONCE THERE, THE VICTIM EXPERIENCES A SERIES OF SYMPTOMS THAT ARE INGENIOUSLY EVOLVED TO CONTINUE THE SPREAD OF THE DISEASE. THE INFECTED WILL LOSE THE ABILITY TO SWALLOW AND DEVELOP AN INTENSE FEAR OF WATER (HYDROPHOBIA), MEANING THAT THE SALIVA (WHICH IS LOADED WITH THE RABIES VIRUS) REMAINS POTENT IN THE MOUTH. THIS INTENSE THIRST IS PAIRED WITH FITS OF RAGE, COMPELLING THE INFECTED TO BITE ANOTHER CREATURE AND SPREAD THE INFECTION.

Am I Seeing Things . . .
Or being slowly poisoned

SOME GHOST ENCOUNTERS ARE CAUSED BY
CARBON MONOXIDE POISONING.*

CARBON MONOXIDE LEAKS (AROUND SINCE THE INVENTION
OF THE GAS LAMP) PRODUCE A COLORLESS, ODORLESS GAS
THAT BONDS TO HEMOGLOBIN IN THE BLOODSTREAM, WHICH
CAUSES IT TO FAIL TO DELIVER OXYGEN TO THE BODY AND
BRAIN. CARBON MONOXIDE CAN CREATE A SENSATION OF HEAVY
FEELING ON THE CHEST, CAUSE AUDITORY HALLUCINATIONS,
AND A FEELING OF DEEP DREAD.

*AUTHOR STILL BELIEVES IN AND IS TERRIFIED OF GHOSTS
DESPITE CONFLICTING SCIENTIFIC DATA.

Earth Science

The study of the physical constitution of Earth
and its atmosphere

Geology
Geophysics
Glaciology
Meteorology
Oceanography

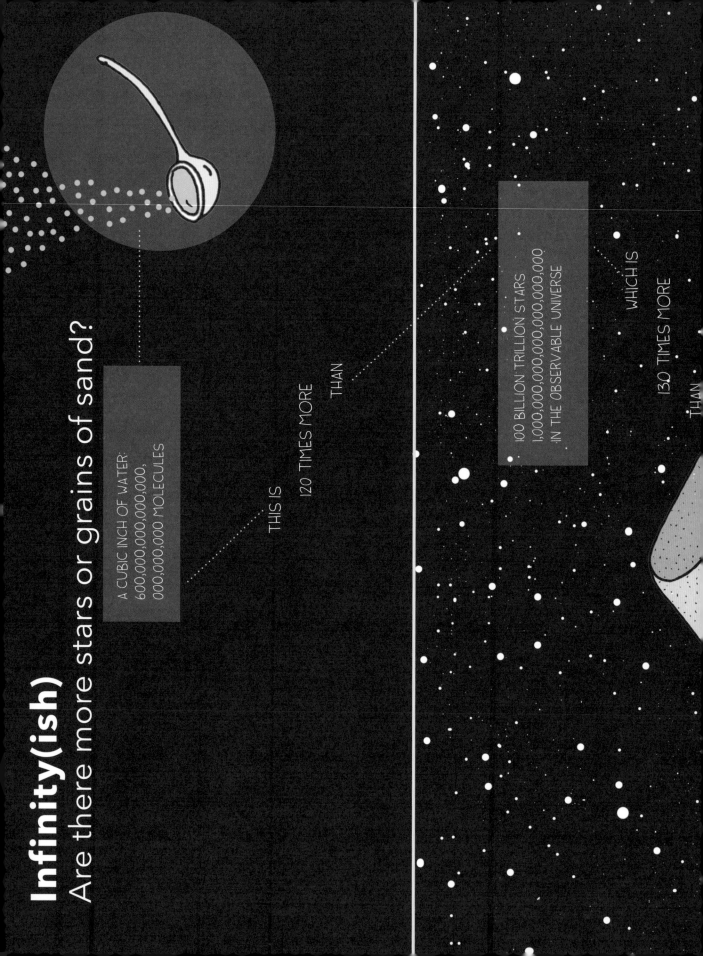

Infinity(ish)
Are there more stars or grains of sand?

A CUBIC INCH OF WATER:
600,000,000,000,
000,000,000 MOLECULES

THIS IS

120 TIMES MORE

THAN

100 BILLION TRILLION STARS
1,000,000,000,000,000,000,000
IN THE OBSERVABLE UNIVERSE

WHICH IS

130 TIMES MORE

THAN

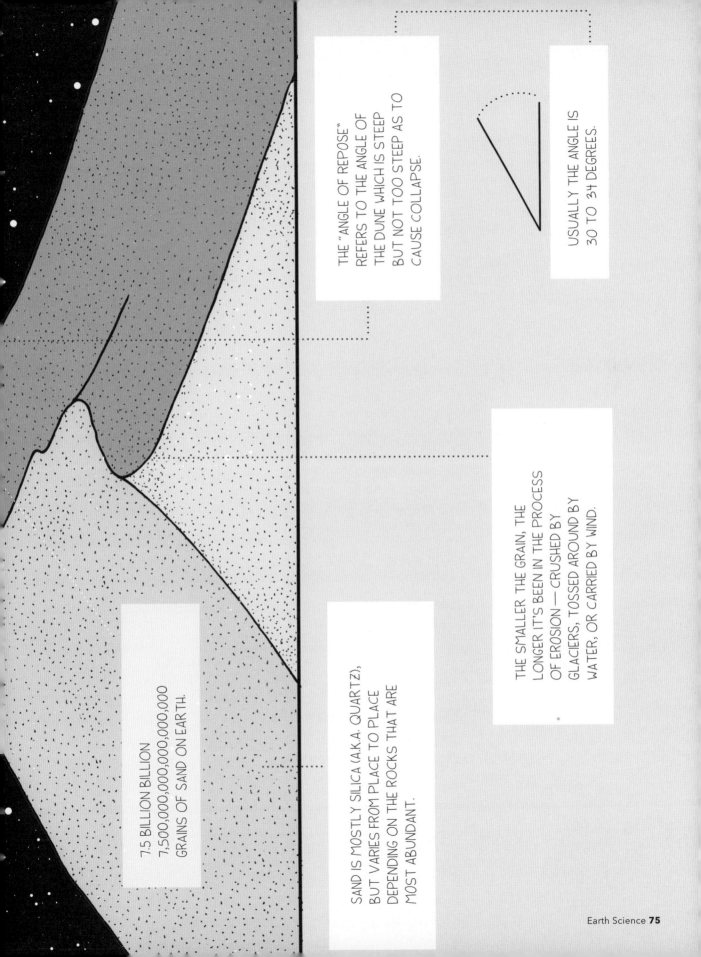

THE "ANGLE OF REPOSE" REFERS TO THE ANGLE OF THE DUNE WHICH IS STEEP BUT NOT TOO STEEP AS TO CAUSE COLLAPSE.

USUALLY THE ANGLE IS 30 TO 34 DEGREES.

THE SMALLER THE GRAIN, THE LONGER IT'S BEEN IN THE PROCESS OF EROSION — CRUSHED BY GLACIERS, TOSSED AROUND BY WATER, OR CARRIED BY WIND.

7.5 BILLION BILLION
7,500,000,000,000,000,000
GRAINS OF SAND ON EARTH.

SAND IS MOSTLY SILICA (A.K.A. QUARTZ), BUT VARIES FROM PLACE TO PLACE DEPENDING ON THE ROCKS THAT ARE MOST ABUNDANT.

Photosynthesis
A.K.A. eating sunlight

THERE IS A BEAUTIFUL, BALANCED EXCHANGE
BETWEEN GREEN PLANTS, ALGAE, BACTERIA,
AND ANIMALS. THIS GIVE AND TAKE OF OXYGEN
AND CARBON DIOXIDE IS ESSENTIAL FOR LIFE.

Chloroplasts: THE HUB OF CHEMICAL
REACTIONS IN A PLANT CELL. THYLAKOIDS
ARE SACS WITHIN THE CHLOROPLASTS
THAT HOUSE KEY CHEMICALS FOR THE
PHOTOSYNTHETIC PROCESS.

Chlorophyll: A PIGMENT WITHIN
CHOLORPLASTS THAT ABSORBS ALL
LIGHT EXCEPT GREEN, WHICH IS WHY
PLANTS ARE GREEN.

THE FIRST STAGE OF PHOTOSYNTHESIS REQUIRES SUNLIGHT. WHEN SOLAR ENERGY (LIGHT) INTERACTS WITH THE ELECTRONS IN THE CHLOROPLASTS, THEY BEGIN A SERIES OF CHEMICAL REACTIONS, CREATING ATP (ADENOSINE TRIPHOSPHATE) AND NADPH (NICOTINAMIDE ADENINE DINUCLEOTIDE PHOSPHATE). THE H_2O MOLECULES SPLIT IN THE PROCESS, RELEASING THE MOST USEFUL MOLECULE FOR BREATHING BEINGS, OXYGEN.

AFTER THE H_2O NO LONGER HAS ITS OXYGEN (IT IS NOW IN THE ATMOSPHERE), THE HYDROGEN HELPS THE PLANT'S INTAKE OF CARBON DIOXIDE. THIS PROCESS IS CALLED CARBON FIXATION, WHICH IS A CRUCIAL FACTOR IN COMBATTING GLOBAL WARMING'S ABUNDANCE OF CO_2.

Leaf Shapes
What's going on up there

DIFFERENT SHAPES OF LEAVES ARE CAREFULLY ADAPTED
TO THE PLANT'S ENVIRONMENT TO CONSERVE THE MOST
ENERGY WHILE MAXIMIZING SUNLIGHT COLLECTION.

DARKER LEAVES ABSORB MORE LIGHT ENERGY WHILE

LIGHTER LEAVES REFLECT EXCESS LIGHT TO AVOID OVERHEATING.

ROUGH-SURFACED LEAVES HAVE MORE SURFACE AREA
THAN THEIR SMOOTH COUNTERPARTS, ALLOWING MORE
WATER TO EVAPORATE AND HELPING TO COOL THE TREE.

BROAD LEAVES AT THE TOPS OF TREES ARE SMALLER, LIGHTER IN
COLOR, AND MORE LOBED (WAVY AROUND THE EDGES), PROVIDING AMPLE
HEAT DISPERSAL AND ALLOWING LIGHT TO REACH THE LOWER, LARGER,
LESS-LOBED LEAVES. LOBES DISPERSE HEAT BY PROVIDING MORE POINTS
OF EVAPORATION (ALSO KNOWN AS EVAPOTRANSPIRATION).

NEEDLES HAVE LESS SURFACE AREA AND DARKER COLORATION THAN
BROAD LEAVES, BUT BY BEING EVERGREEN (YEAR-ROUND), THE TREES
SAVE ENERGY IN THE LONG RUN BY AVOIDING THE ENERGY-HEAVY
PROCESS OF REGROWING ALL LEAVES YEARLY.

NEEDLES

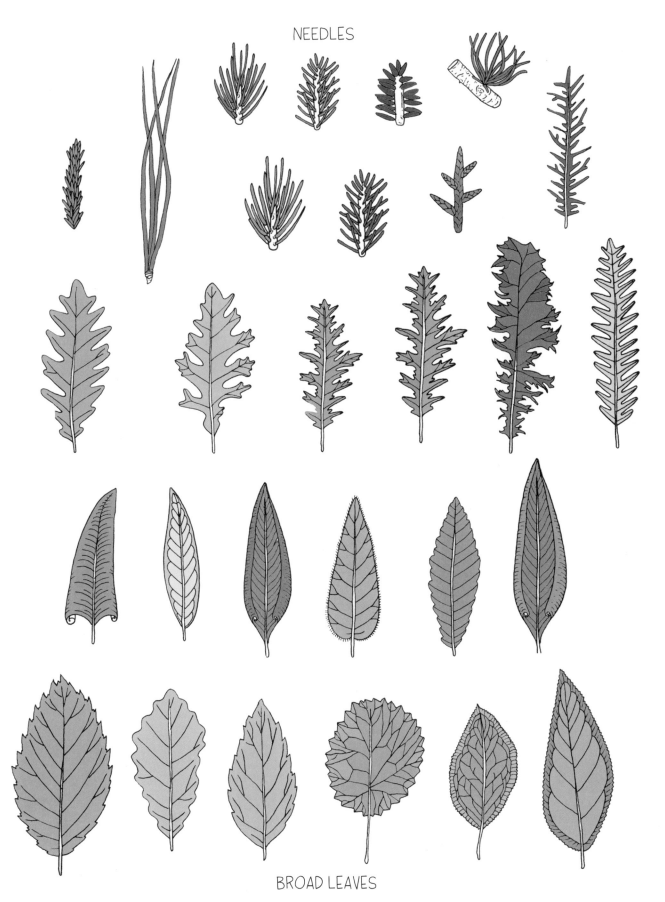

BROAD LEAVES

How to Grow
Out of thin air

A thinking exercise

IMAGINE ONE OF THE WORLD'S LARGEST LIVING ORGANISMS: A REDWOOD TREE. WHERE DOES THE ENORMOUS MASS OF THAT TREE COME FROM? YOU MIGHT AUTOMATICALLY ASSUME THAT IT RISES UP FROM THE EARTH AROUND AND BELOW IT WITH THE HELP OF SOIL AND WATER, BECAUSE WHERE ELSE COULD IT BE FROM?

THE AIR.

WAIT, WHAT?

THE AIR.

REDWOOD TREES (MOSTLY) MATERIALIZE OUT OF THIN AIR. THE PRIMARY SUBSTANCE OF TREES AND PLANT MATTER IS CARBON, WHICH IS ABSORBED FROM THE ATMOSPHERE IN THE FORM OF CO_2 (CARBON DIOXIDE). ONCE INSIDE THE TREE'S LEAVES, SUNLIGHT REACTS WITH CO_2 AND RELEASES OXYGEN AS A BY-PRODUCT (THE STUFF WE BREATHE IN), STORING THE CARBON AS A BUILDING BLOCK.

AS FAR AS WATER AND ENERGY GO, THE SUN, RAIN, FOG, AND ATMOSPHERIC MOISTURE PROVIDE ALMOST ALL THE WATER CONSUMED BY A REDWOOD, WHICH IS VERY ADAPTED TO ABSORB WATER THROUGH ITS NEEDLE-SHAPED LEAVES IN THE FOGGY CLIMATE. FOR FOOD, THEY PRODUCE GLUCOSE FROM PHOTOSYNTHESIZING SUNLIGHT.

TREES GET TRACE NUTRIENTS AND SOME WATER FROM THE SOIL, BUT THEIR SIZE AND WEIGHT IS BUILT ON ELEMENTS FROM THEIR ATMOSPHERIC ENVIRONMENT.

Note: THIS IS APPLICABLE TO MANY PLANTS. REDWOODS ARE JUST A PARTICULARLY IMPRESSIVE EXAMPLE.

Landforms
Plateauing at the top of the world

A PLATEAU IS A RAISED, FLAT-TOPPED (OR MOSTLY FLAT) LANDFORM THAT CAN BE CAUSED BY A NUMBER OF GEOLOGICAL PROCESSES, INCLUDING GLACIER MOVEMENT, VOLCANIC LAVA FLOW, AND WIND OR RAIN EROSION.

AT 604,000 SQUARE MILES, THE TIBETAN PLATEAU, APTLY NICKNAMED "THE ROOF OF THE WORLD" OR "THE THIRD POLE," IS THE LARGEST PLATEAU ON EARTH. THE HIGH PLAIN IS CRADLED AMONG THE WORLD'S YOUNGEST AND THEREFORE TALLEST MOUNTAINS, THE HIMALAYAS.

(FOR REFERENCE, THE CONTINENTAL UNITED STATES OCCUPIES AN AREA OF 3,119,884 SQUARE MILES.)

BECAUSE THIS PLAIN IS SO ELEVATED (16,000 FEET IN ALTITUDE), IT IS HOME TO THOUSANDS OF GLACIERS (37,000 TO BE EXACT), WHICH PROVIDE FRESH WATER TO A HUGE SURROUNDING AREA. AS THE CLIMATE IS CHANGING, THE GLACIERS HAVE BEGUN TO MELT MORE QUICKLY THAN THEY CAN REFORM, THREATENING THE WATER SUPPLY OF MORE THAN 2 BILLION PEOPLE.

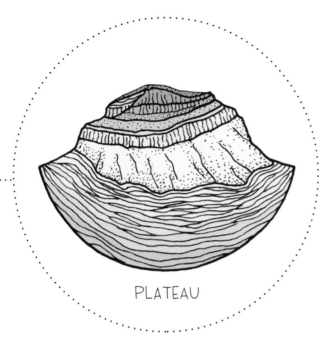

PLATEAU

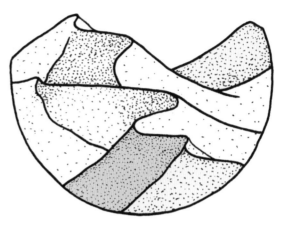

DUNE

V-SHAPED VALLEY

U-SHAPED VALLEY

MOUNTAIN

ISLAND

Glaciation:
As explained by a Snickers

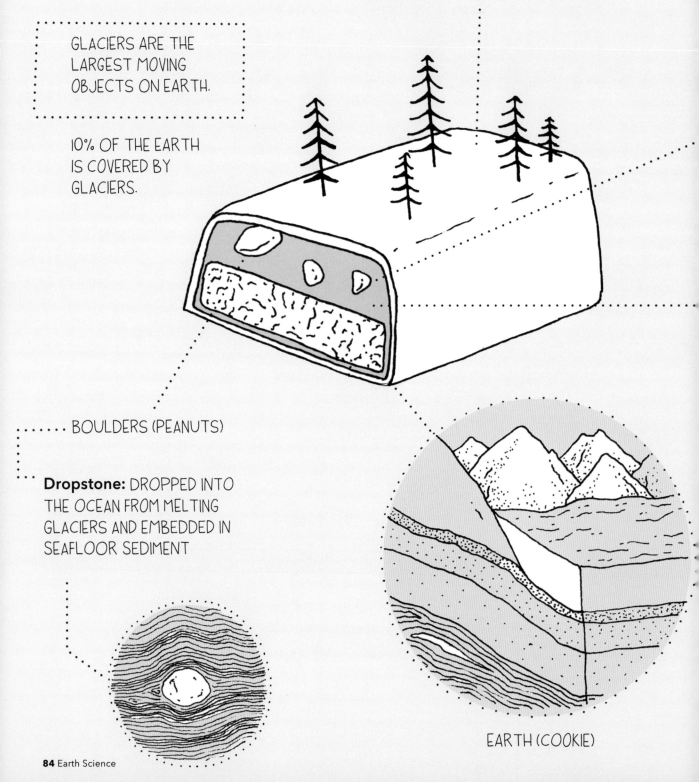

FRESH SNOW (CHOCOLATE COATING)

GLACIERS ARE THE LARGEST MOVING OBJECTS ON EARTH.

10% OF THE EARTH IS COVERED BY GLACIERS.

BOULDERS (PEANUTS)

Dropstone: DROPPED INTO THE OCEAN FROM MELTING GLACIERS AND EMBEDDED IN SEAFLOOR SEDIMENT

EARTH (COOKIE)

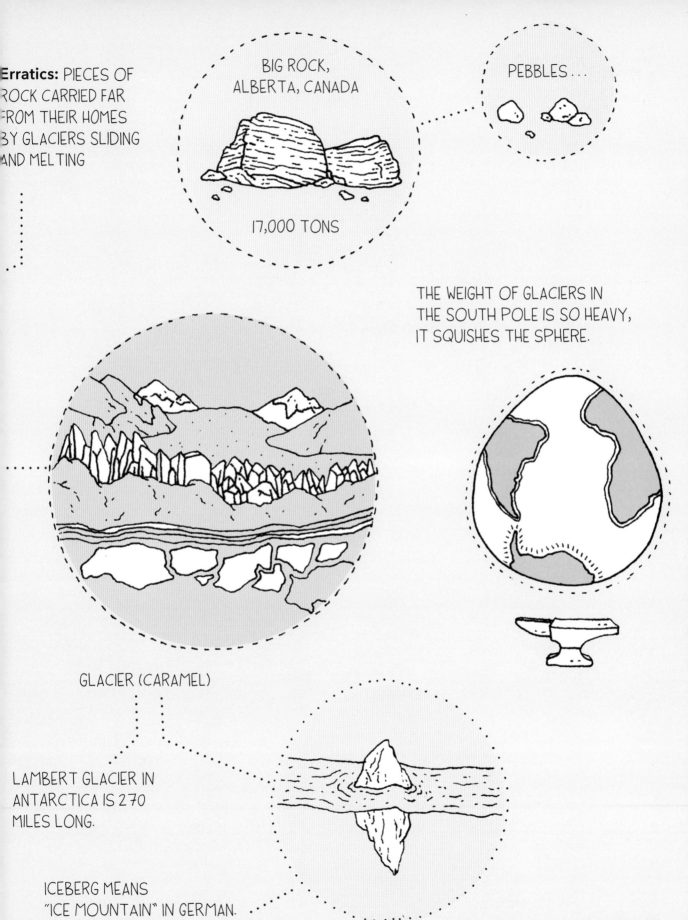

Erratics: PIECES OF ROCK CARRIED FAR FROM THEIR HOMES BY GLACIERS SLIDING AND MELTING

BIG ROCK, ALBERTA, CANADA

17,000 TONS

PEBBLES...

THE WEIGHT OF GLACIERS IN THE SOUTH POLE IS SO HEAVY, IT SQUISHES THE SPHERE.

GLACIER (CARAMEL)

LAMBERT GLACIER IN ANTARCTICA IS 270 MILES LONG.

ICEBERG MEANS "ICE MOUNTAIN" IN GERMAN.

Death Valley's sliding rocks

ON THE RACETRACK PLAYA IN DEATH VALLEY NATIONAL PARK, CALIFORNIA, THERE ARE HUGE STONES (SOMETIMES WEIGHING UP TO 600 POUNDS) THAT MOVE ACROSS THE DESERT PLAIN, CREATING DRAG MARKS THROUGH THE CRACKED EARTH.

HOW THEY MOVE HAS BEEN A COMPLETE MYSTERY UNTIL RECENTLY.

IN ORDER FOR THE ROCKS TO MOVE,
THERE MUST BE A PERFECT (AND RARE)
SET OF WEATHER CONDITIONS.

The Ingredients:

1. ENOUGH WATER TO FILL THE PLAYA, BUT NOT SO
MUCH THAT IT WOULD COVER THE ROCKS COMPLETELY.
FILLING THE PLAYA WITH WATER IS A RARE ENOUGH
CONDITION FOR THIS INCREDIBLY DRY REGION.

2. NIGHTTIME TEMPERATURES LOW ENOUGH TO FORM
"WINDOWPANE" ICE (A VERY THIN SHEET THAT FLOATS
ON TOP OF THE PLAYA) BUT NOT SO LOW AS TO
FORM A THICK ICE SHEET.

3. A LIGHT WIND DURING THE DAY.

WHEN THE COMBINATION IS JUST RIGHT,
THE ICE MELTS ENOUGH TO BREAK APART.
THE WIND SCOOTS THE STONES THROUGH
THE SOFTENED MUD.

Caves
No need to be in the dark

MAMMILARIES OR CAVE CLOUDS

CAVES ARE FORMED WHEN RAIN
WATER FLOWS THROUGH CRACKS
IN CALCIUM RICH ROCKS, GENERALLY
LIMESTONE OR DOLOMITE.
 $H_2O + CO_2$ FORMS CARBONIC
ACID, WHICH DISSOLVES THE
SURROUNDING ROCK.

COLUMNS
(WHEN STALAGMITES AND
STALAGTITES MEET)

SHELFSTONE

BATHTUBS

STALAGMITE

STALACTITE

WATER CONTAINING THE
DISSOLVED LIMESTONE THAT
DRIPS FROM THE CEILING BEGINS
TO CREATE THE FORMATIONS
WITHIN THE CAVE, CALLED
SPELEOTHEMS. THE WATER
EVAPORATES, LEAVING
LIMESTONE FORMATIONS.
 THE TYPE OF FORMATION
IS DEPENDENT ON THE
WAY THE WATER FLOWS.

SELENITE CRYSTALS IN
MEXICO'S CAVE OF THE
CRYSTALS HAVE GROWN
UP TO 40 FEET LONG.

HELICTITES

SPLATTERMITES

PHYTOKARST

Mountains

Seamounts

UNDERWATER MOUNTAINS THAT REACH HEIGHTS OF 1,000 METERS
OR MORE FROM THE SEAFLOOR, BUT DO NOT REACH THE SURFACE
OF THE WATER ARE CALLED SEAMOUNTS. THERE ARE 9,951 OF
THEM ON RECORD. THESE GEOLOGICAL FORMATIONS ARE CREATED
BY VOLCANIC ACTIVITY AND SERVE AS BIOLOGICAL HOT SPOTS.
THE LARGE PROTRUSIONS FROM THE SEAFLOOR DISRUPT WATER
CURRENTS, CREATING NUTRIENT UPWELLINGS IN OTHERWISE
STAGNANT, OXYGEN-POOR DEEP WATERS. CORAL THRIVES, CREATING
HABITATS AND FOOD SOURCES FOR CREATURES LARGE AND SMALL.
IF THERE IS AN UNDERWATER LANDSLIDE, IT CAN CREATE A TSUNAMI.

Magnetic Striping
On the ocean floor

FIRSTLY, WHAT ARE MAGNETS AND HOW DO THEY AFFECT EARTH?

A MAGNET IS A FERROUS SUBSTANCE (IRON RICH) THAT CREATES A FIELD AROUND IT WHICH ATTRACTS OTHER FERROUS SUBSTANCES. THE EARTH'S CORE IS IRON, WHICH CREATES A MAGNETIC FIELD SO LARGE IT REACHES THE SOLAR WINDS.

BECAUSE THE MAGNETIC FIELD IS DETERMINED BY THE MOLTEN IRON CORE, IT IS NOT FIXED DIRECTIONALLY, MEANING MAGNETIC NORTH IS NOT ALWAYS IN THE SAME LOCATION OR DIRECTION OVER TIME.

GENERALLY THIS SHIFTING OF THE EARTH'S MAGNETIC FIELD IS GRADUAL, BUT EVERY SO OFTEN (WHICH IN GEOLOGIC TIME IS HUNDREDS OF THOUSANDS OF YEARS) THE POLES ABRUPTLY SWITCH LOCATIONS. CURRENTLY, GEOGRAPHIC NORTH POLE IS THE SOUTH END OF THE MAGNETIC FIELD.

SO, WHAT DOES THIS HAVE TO DO WITH THE OCEAN FLOOR?

THE SEAFLOOR SERVES AS A GEOLOGICAL RECORD OF WHEN THE POLE SWITCHES OCCURED OVER TIME. IN AREAS WHERE TECTONIC PLATES MEET UNDERWATER, MAGMA IS RELEASED FROM BENEATH THE CRUST, WHICH CONTAINS TONS OF IRON. AS THE MOLTEN ROCK COOLS, THE IRON SOLIDIFIES IN THE DIRECTION OF THE MAGNETIC POLES.

THE SEAFLOOR IN THESE LOCATIONS REVEAL, THE STRIPING OF DIRECTIONAL CHANGES IN THE IRON ROCK.

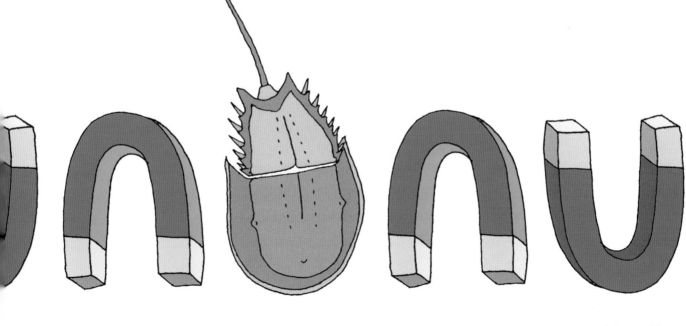

Tides

A push and pull of more water than you can possibly imagine*

SPRING TIDE

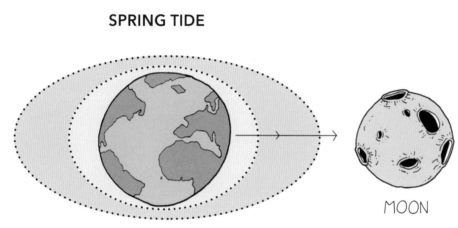

MOON

WHEN THE GRAVITATIONAL PULL OF
THE SUN AND MOON ARE ALIGNED, THE
TIDES ARE MORE EXTREME, CREATING
SPRING TIDES.

*A CUBIC MILE OF WATER = 1.1 TRILLION GALLONS

THERE ARE APPROXIMATELY 332,500,000 CUBIC
MILES (MI³) OF WATER ON EARTH.

WHEN THE MOON AND SUN PULL IN DIFFERENT DIRECTIONS, THERE IS LESS PULL ON THE OCEAN, CALLED A NEAP TIDE.

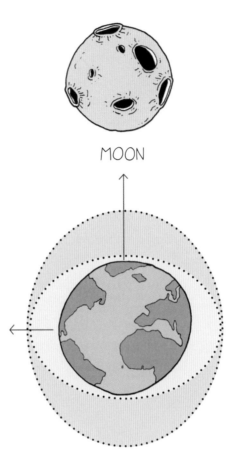

MOON

NEAP TIDE

SUN

THE GRAVITATIONAL PULL ON THE EARTH'S WATER IS MUCH STRONGER FROM THE MOON THAN FROM THE SUN.

Tsunamis
Wave hello

TSUNAMIS ARE THE RESULT OF
UNDERWATER EARTHQUAKES.
THE FORCE OF TECTONIC PLATE
MOVEMENT ON THE SEAFLOOR DISPLACES
ENORMOUS AMOUNTS OF ENERGY INTO
THE WATER ABOVE THE EARTHQUAKE.

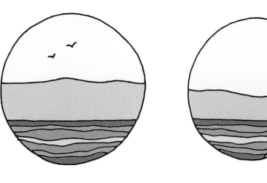

CALM

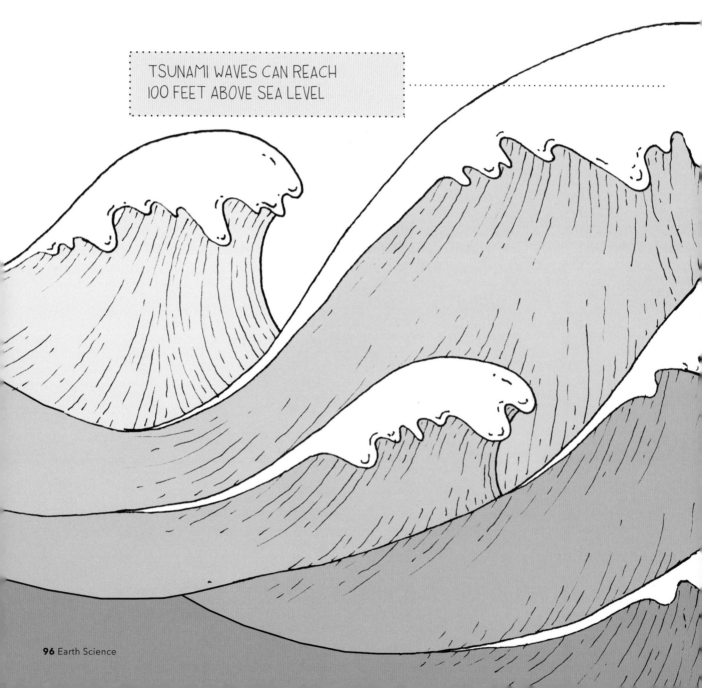

TSUNAMI WAVES CAN REACH
100 FEET ABOVE SEA LEVEL

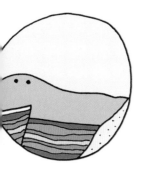

EARTHQUAKE UNDERWATER TSUNAMI

WAVES OF ALL KINDS ARE THE MOVEMENT OF
ENERGY THROUGH A MEDIUM. OCEAN WAVES ARE
CAUSED BY ENERGY MOVING THROUGH WATER
RATHER THAN THE MOVEMENT OF THE WATER
ITSELF, THOUGH THAT IS THE BY-PRODUCT.
TYPICAL WAVES ARE CAUSED BY WIND, FRICTION
BETWEEN THE SURFACE WATER MOLECULES
AND THE AIR ABOVE.

AND UP TO 500 MPH

Whale Falls:
Death that creates an ecosystem

Ecosystem: A BIOLOGICAL COMMUNITY OF INTERACTING ORGANISMS AND THEIR PHYSICAL ENVIRONMENT.

ECOSYSTEMS CAN BE INCREDIBLY DIVERSE IN BOTH SCALE AND PLAYERS INVOLVED. ON A SMALL SCALE, YOUR BODY IS AN ECOSYSTEM WITH BILLIONS OF TEENY ORGANISMS WORKING TO FUNCTION AS A WHOLE SYSTEM (YOU). ON A LARGE SCALE, THE ENTIRE AMAZON RAIN FOREST IS AN ECOSYSTEM KNOWN AS A BIOME WITH DISTINCT ECOSYSTEMS WITHIN IT.

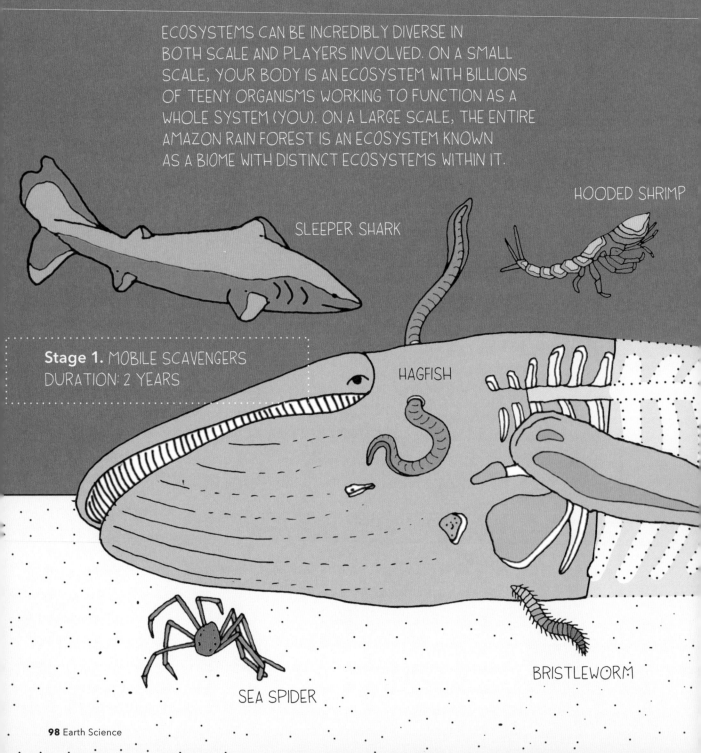

SLEEPER SHARK

HOODED SHRIMP

Stage 1. MOBILE SCAVENGERS
DURATION: 2 YEARS

HAGFISH

SEA SPIDER

BRISTLEWORM

WHEN A WHALE DIES AND SINKS TO DEPTHS OF MORE
THAN 3,300 FEET (KNOWN AS THE ABYSSAL OR BATHYAL
ZONE), THE WATER IS COLD ENOUGH TO SLOW
DECOMPOSITION AND FORM A TEMPORARY ECOSYSTEM
WHERE NUTRIENT-RICH SOURCES ARE HARD TO COME BY.

Stage 2. ENRICHMENT OPPORTUNISTS
DURATION: 2 YEARS

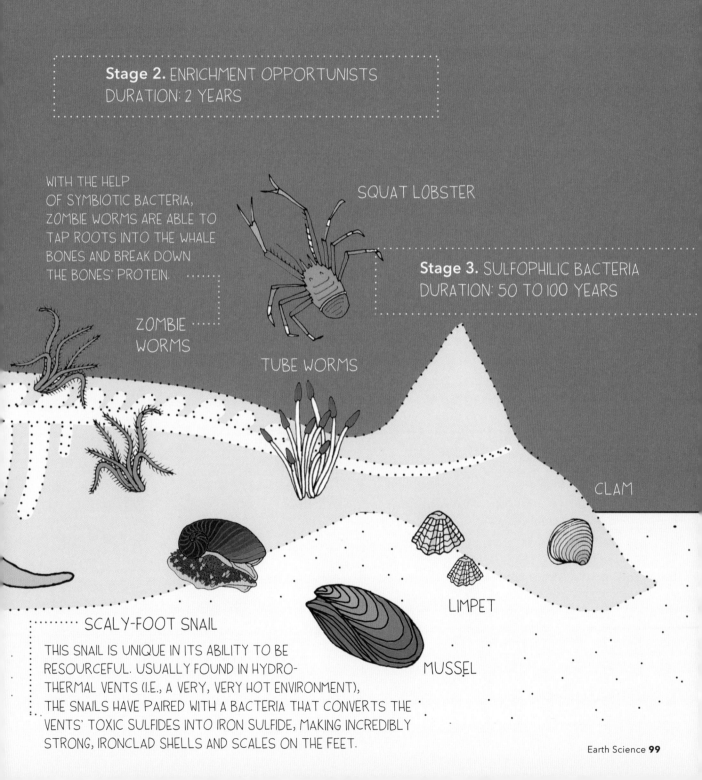

WITH THE HELP
OF SYMBIOTIC BACTERIA,
ZOMBIE WORMS ARE ABLE TO
TAP ROOTS INTO THE WHALE
BONES AND BREAK DOWN
THE BONES' PROTEIN.

SQUAT LOBSTER

Stage 3. SULFOPHILIC BACTERIA
DURATION: 50 TO 100 YEARS

ZOMBIE
WORMS

TUBE WORMS

CLAM

LIMPET

SCALY-FOOT SNAIL

MUSSEL

THIS SNAIL IS UNIQUE IN ITS ABILITY TO BE
RESOURCEFUL. USUALLY FOUND IN HYDRO-
THERMAL VENTS (I.E., A VERY, VERY HOT ENVIRONMENT),
THE SNAILS HAVE PAIRED WITH A BACTERIA THAT CONVERTS THE
VENTS' TOXIC SULFIDES INTO IRON SULFIDE, MAKING INCREDIBLY
STRONG, IRONCLAD SHELLS AND SCALES ON THE FEET.

Ocean Acidification
When life gives you lemons, throw them in the sea

THE OCEAN IS BECOMING LESS ALKALINE, OR BASIC, AS A PRODUCT OF INCREASED CO_2 IN THE ATMOSPHERE. OCEAN WATER, WHICH IS MORE BASIC (pH OF 8.2) THAN PURE WATER (pH OF 7), HAS ACTED LIKE A SPONGE FOR GREENHOUSE GASES, CAUSING ITS pH TO DECREASE 0.1 ON THE LOGARITHMIC pH SCALE. A SMALL CHANGE IN SCALE TRANSLATES TO A 30 PERCENT INCREASE IN ACIDITY.

$$CO_2 + H_2O \rightarrow H_2CO_3$$
TRANSLATION: CARBON DIOXIDE + SEA WATER FORMS CARBONIC ACID

$$H_2CO_3 \text{ (DISSOLVES)} \rightarrow H+ \text{ IONS (ACID)} + HCO^{3-} \text{ (BASE)}$$
TRANSLATION: CARBONIC ACID DISSOLVES, LEAVING HYDROGEN IONS AND BICARBONATE

CO_3^{-2} (BASE ALREADY PRESENT IN OCEAN WATER) NEUTRALIZES H+ IONS
TRANSLATION: THE BASIC CARBONATE ION NEUTRALIZES THE HYDROGEN IONS, WHICH IN TURN CREATES MORE BICARBONATE AND REDUCES THE AMOUNT OF CARBONATE IONS (A KEY BUILDING BLOCK FOR CALCIFEROUS SHELLS)

COLDER WATER DISSOLVES CARBON DIOXIDE MORE QUICKLY THAN WARM WATER. THE POLES ARE BECOMING ACIDIC AT A MUCH FASTER RATE THAN TROPICAL WATERS.

ACIDITY

TIME

CREATURES THAT BUILD CALCIFEROUS
SHELLS ARE MOST AT RISK. THE
SHELLS ARE WEAKER, THINNER,
AND LESS PROTECTIVE FROM
LACK OF AVAILABLE ARAGONITE,
A CALCIUM CARBONATE MINERAL
MORE EASILY ACCESSIBLE THAN
CALCITE (A CONSEQUENCE OF LESS
CARBONATE IONS). DUE TO THEIR
THINNER STRUCTURE, THE SHELLS
ARE LIGHTER IN WEIGHT AND WILL NO
LONGER SINK TO THE BOTTOM OF
THE SEA, AN IMPORTANT ASPECT OF
LONG-TERM CARBON STORAGE.

LIKE FORESTS ON LAND, WHICH
ABSORB CARBON DIOXIDE
AS PART OF THE PHOTO-
SYNTHETIC PROCESS, OCEANIC
FORESTS OF KELP CAN HELP
OFFSET THE ACIDIFICATION
PROCESS BY ABSORBING CO_2
AND RELIEVING THE STRESS ON
CREATURES LESS ABLE TO
ADAPT TO THE RISING LEVELS
OF CO_2.

River Flows
Wandering water shapes

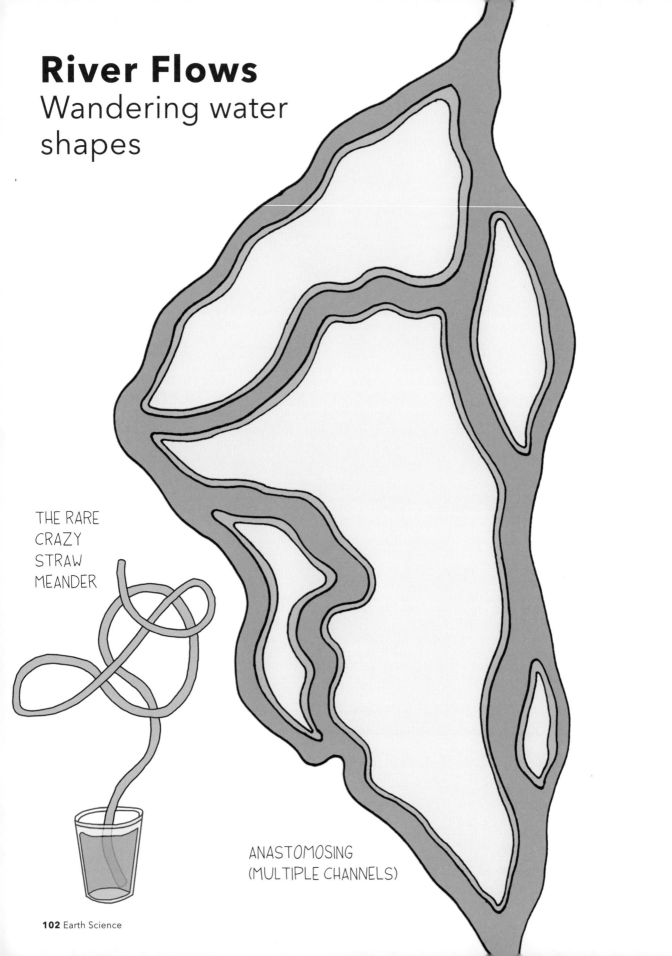

THE RARE
CRAZY
STRAW
MEANDER

ANASTOMOSING
(MULTIPLE CHANNELS)

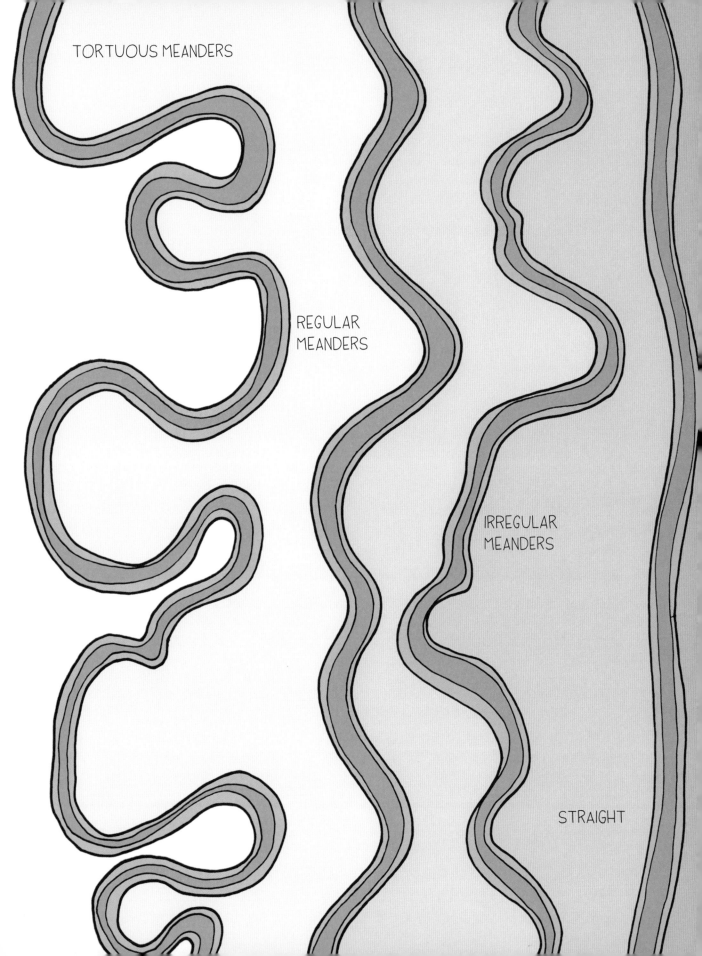

TORTUOUS MEANDERS

REGULAR
MEANDERS

IRREGULAR
MEANDERS

STRAIGHT

Clouds

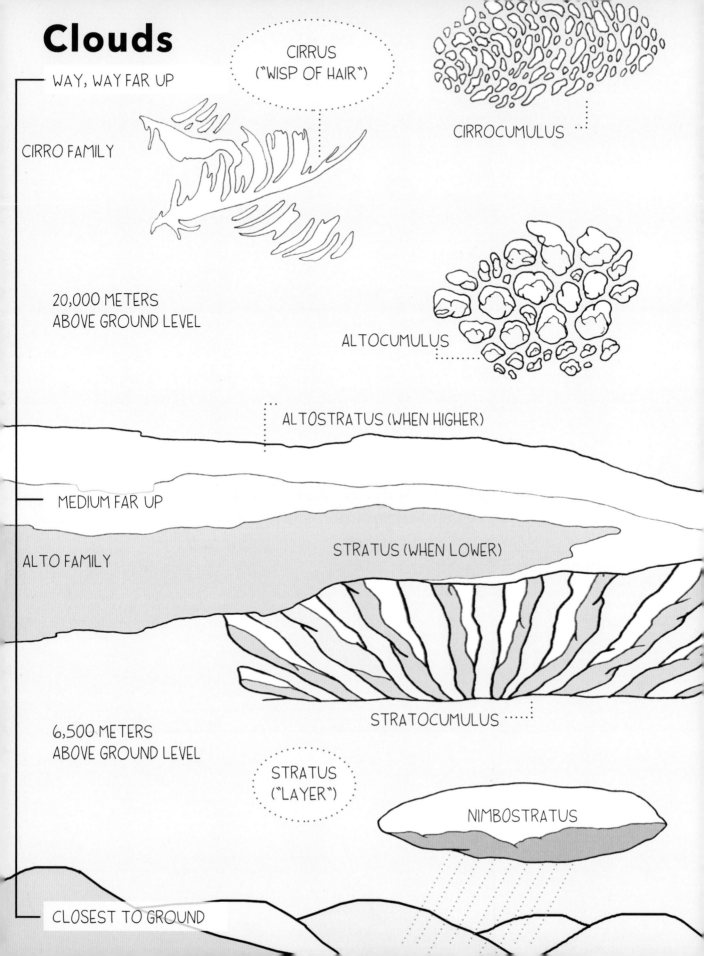

WAY, WAY FAR UP

CIRRUS ("WISP OF HAIR")

CIRRO FAMILY

CIRROCUMULUS

20,000 METERS ABOVE GROUND LEVEL

ALTOCUMULUS

ALTOSTRATUS (WHEN HIGHER)

MEDIUM FAR UP

ALTO FAMILY

STRATUS (WHEN LOWER)

STRATOCUMULUS

6,500 METERS ABOVE GROUND LEVEL

STRATUS ("LAYER")

NIMBOSTRATUS

CLOSEST TO GROUND

CLOUD FORMATION VARIES WITH A NUMBER OF CIRCUMSTANCES: TEMPERATURE, ALTITUDE, GEOGRAPHICAL FEATURES, OR WHAT'S IN THE AIR FOR WATER DROPLETS TO GRAB ONTO, KNOWN AS NUCLEATORS — THESE CAN BE DUST PARTICLES, BACTERIA, SALT, OR OTHER PARTICULATES.

WHILE NUCLEATORS HELP WATER MOLECULES GATHER TO FORM CLOUDS, TOO MANY OF THEM CAN HAVE NEGATIVE IMPACTS ON AN AREA. TAKE DUST FOR EXAMPLE: IF YOU HAVE 20 DUST PARTICLES, THE AVAILABLE MOISTURE IN THE AIR WILL CLUMP ONTO THOSE 20 POINTS, FORMING PRETTY LARGE DROPLETS. IF THAT NUMBER OF PARTICLES INCREASES (IN A VERY DUSTY AREA OR IN AN UNUSUALLY DRY SUMMER), THE SAME AMOUNT OF AVAILABLE AMBIENT MOISTURE MIGHT HAVE 2,000 DUST PARTICLES AVAILABLE. THIS CREATES MUCH SMALLER, LIGHTER WATER DROPLETS THAT AREN'T HEAVY ENOUGH TO FALL, LEADING TO A CYCLE OF DROUGHT AND DESERTIFICATION.

NIMBUS
("RAINY")

CUMULONIMBUS

CUMULUS
("HEAP/PILE")

RAIN OCCURS WHEN ONE CLOUD DROPLET ATTRACTS ENOUGH H_2O MOLECULES TO FALL FROM THE FORCE OF GRAVITY.

Physical Science

The study of inanimate natural objects

Astronomy
Chemistry
Physics

Cosmic Calendar

JANUARY 1ST UNTIL JANUARY 1ST ONE YEAR LATER.
13.8 BILLION YEARS IN 365 DAYS

Jan 1: BIG BANG

Jan 22: FIRST GALAXIES FORM

March 16: MILKY WAY GALAXY IS FORMED

Sept 2: OUR SOLAR SYSTEM IS FORMED

Sept 6: BIRTHDAY OF EARTH'S OLDEST ROCKS

Sept 21: PROKARYOTES (SINGLE-CELL ORGANISMS) ARRIVE ON THE SCENE

Sept 30: PHOTOSYNTHESIS DEVELOPS

Oct 29: ATMOSPHERE BECOMES OXYGENATED AS RESULT OF PHOTOSYNTHETIC CYANOBACTERIA. BECAUSE OXYGEN WAS NOT IN SUCH QUANTITIES PREVIOUSLY, THE INCREASE CAUSED A MASSIVE EXTINCTION OF ANAEROBIC (DON'T TAKE IN OXYGEN) ORGANISMS. NOT ONLY DID THE OXYGENATION CAUSE WIDE DIE-OFFS, BUT IT ALSO TRIGGERED THE LONGEST ICE AGE (A.K.A. "SNOWBALL EARTH") BY REDUCING THE AMOUNT OF METHANE (A GREENHOUSE GAS).

Nov 9: EUKARYOTES DEVELOP

Dec 14: ARTHROPODS

Dec 17: FISH, PROTO AMPHIBIANS

Dec 20: LAND PLANTS

Dec 21: INSECTS, SEEDS

Dec 22: AMPHIBIANS

Dec 23: REPTILES

Dec 24: PERMIAN TRIASSIC EXTINCTION
(90% OF SPECIES DIE OUT)

Dec 24: PANGAEA FORMS

Dec 25: DINOSAURS

Dec 26: MAMMALS

Dec 27: BIRDS

Dec 28: FLOWERS

Dec 30: CRETACEOUS PALEOGENE EXTINCTION (ALL
NON-AVIAN DINOSAURS BECOME EXTINCT)

Dec 31, 6:05: APES

Dec 31, 14:24: HOMINIDS

Dec 31, 22:24: TOOLS

Dec 31, 23:44: FIRE

Dec 31, 23:52: HUMANS

The Four Fundamental Forces of Physics
What holds the universe together

THE FOUR FUNDAMENTAL FORCES ARE RESPONSIBLE FOR KEEPING EVERYTHING BEYOND US, AROUND US, AND INSIDE US INTACT, FROM MAINTAINING SOLAR SYSTEM ORBITS TO HOLDING TOGETHER THE SMALLEST SUBATOMIC BUILDING BLOCKS. THE FOUR FORCES RANGE IN SCALE AND STRENGTH, WITH STRONG NUCLEAR FORCE BEING BY FAR THE STRONGEST BUT IT HAS THE SMALLEST RANGE (QUANTUM PARTICLE-LEVEL SMALL). GRAVITY ON THE OTHER HAND IS THE WEAKEST BUT HAS THE LARGEST RANGE (ENTIRE UNIVERSE-LEVEL LARGE).

Electromagnetic Force

THE ELECTROMAGNETIC FORCE IS A COMBINATION OF ELECTRIC AND MAGNETIC FORCES ON PARTICLES. THIS FORCE KEEPS THE ELECTRONS ORBITING AROUND A STRONGLY POSITIVE NUCLEUS AND FOR LARGER ELEMENTS, BRINGS IN MORE ELECTRONS TO BALANCE THE CHARGE.

Strong Nuclear Force

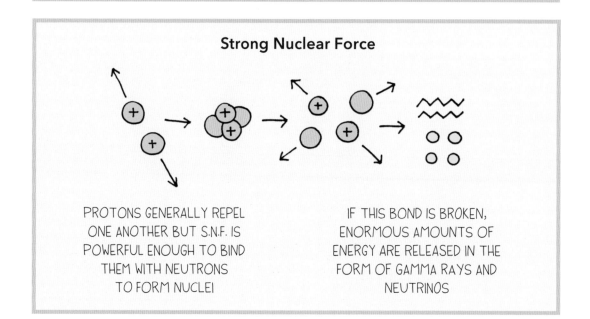

PROTONS GENERALLY REPEL ONE ANOTHER BUT S.N.F. IS POWERFUL ENOUGH TO BIND THEM WITH NEUTRONS TO FORM NUCLEI

IF THIS BOND IS BROKEN, ENORMOUS AMOUNTS OF ENERGY ARE RELEASED IN THE FORM OF GAMMA RAYS AND NEUTRINOS

Weak Nuclear Force

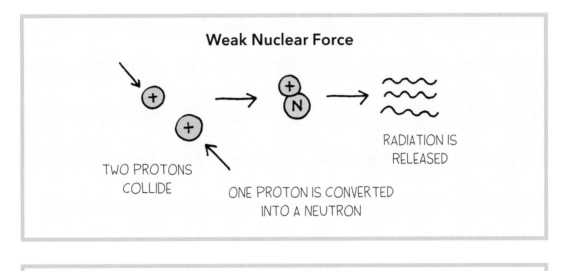

TWO PROTONS
COLLIDE

ONE PROTON IS CONVERTED
INTO A NEUTRON

RADIATION IS
RELEASED

Gravity

OBJECTS WITH MASS ARE PULLED
TOWARD ONE ANOTHER

Weak Social Force
LITTLE KNOWN 5TH FORCE
MASSIVE ENERGY OUTPUT, VERY LITTLE EFFECT

SITTING BETWEEN TWO CONVERSATIONS
BUT NOT BEING PART OF EITHER ONE

The Physics of Touch
You might not be touching this page

IT'S ONE OF PHYSICS' MORE POP-SCI FACTS, THAT WE NEVER
ACTUALLY "TOUCH" ANYTHING, BUT IT'S ONE WORTH EXPLAINING
AS IT INVOLVES QUITE A FEW IMPORTANT AND BASIC PHYSICS PRINCIPLES.

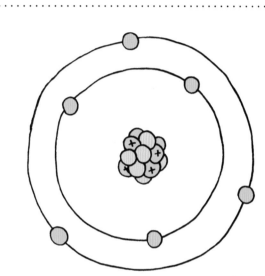

Proton: POSITIVELY
CHARGED PARTICLE

Neutron: NEUTRALLY
CHARGED PARTICLE

Electrons: NEGATIVELY
CHARGED PARTICLES THAT ORBIT
AROUND THE NUCLEUS.
ELECTRONS ARE TINY COMPARED
TO THE NUCLEUS PARTICLES,
WITH A MASS OF ABOUT
1/2000TH OF A PROTON

Nucleus: PROTONS AND
NEUTRONS BOUND
TOGETHER BY STRONG
NUCLEAR FORCE

FIG 4: Structure of an atom

SO, ARE THESE HANDS TOUCHING? YES AND NO. IF "TOUCH" IS DEFINED AS TWO HAND PARTICLES BEING IN THE SAME EXACT LOCATION AT THE SAME EXACT TIME, THEN NO, THEY ARE NOT. IF TOUCH IS DEFINED AS TWO ATOMS BEING CLOSE ENOUGH TO HAVE OVERLAPPING ELECTRON ORBITS AND CLOSE ENOUGH TO INFLUENCE THE ATOMS ON YOUR FRIEND'S HAND TO CREATE THE SENSATION OF TOUCH? THEN YES. BECAUSE ATOMS DO NOT HAVE HARD OR CONSISTENTLY DEFINED BOUNDARIES (ELECTRONS CONSTANTLY MOVE), THE MEANING OF TOUCH GETS A LITTLE HAZY. BUT FOR ALL INTENTS AND PURPOSES, YOU ARE TOUCHING THAT HAND WHEN YOU GIVE A HIGH FIVE.

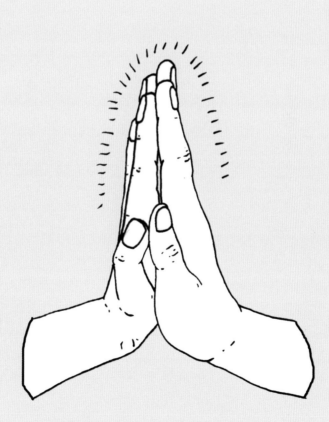

Newton's Third Law

A miniature game of tug-of-war

FOR EVERY ACTION, THERE IS AN EQUAL AND OPPOSITE REACTION.

Uncertainty Principle
or Heisenberg principle

THE VELOCITY OF A PARTICLE AND
THE POSITION OF A PARTICLE
CAN NEVER BE PRECISELY MEASURED
AT THE SAME TIME.

IF YOU INCREASE THE PRECISION
OF MEASURING ONE PROPERTY,
YOU ARE FORCED TO LOSE
PRECISION IN MEASURING THE OTHER.

Quantum Superposition
Similar but different

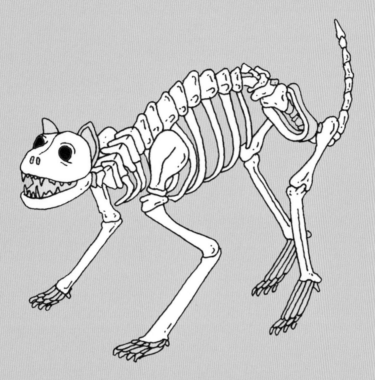

FIG 5: Schrödinger's cat
WHO, EIGHTY-TWO YEARS LATER, IS CERTAINLY
DEAD BY NOW

QUANTUM SUPERPOSITION STATES THAT UNTIL A PARTICLE IS MEASURED AND OBSERVED, IT EXISTS IN ALL POSSIBLE STATES AT ONCE. A CAT PUT IN AN OPAQUE BOX WITH POISON THAT HAS A 50 PERCENT CHANCE OF KILLING THE CAT WILL BE BOTH DEAD AND ALIVE BEFORE OPENING THE BOX TO REVEAL ITS STATE. ONLY WHEN THE OBSERVER OPENS THE BOX DOES THE CAT'S STATE COLLAPSE FROM A SUPERPOSITION OCCUPYING ALL POSSIBLE STATES TO ONLY ONE OF THE POSSIBLE STATES.

SCHRÖDINGER'S CAT-THOUGHT EXPERIMENT WAS CREATED TO ILLUSTRATE THE BIZARRE BEHAVIOR OF QUANTUM PARTICLES.

The Electromagnetic Spectrum
A simple version of a complicated concept

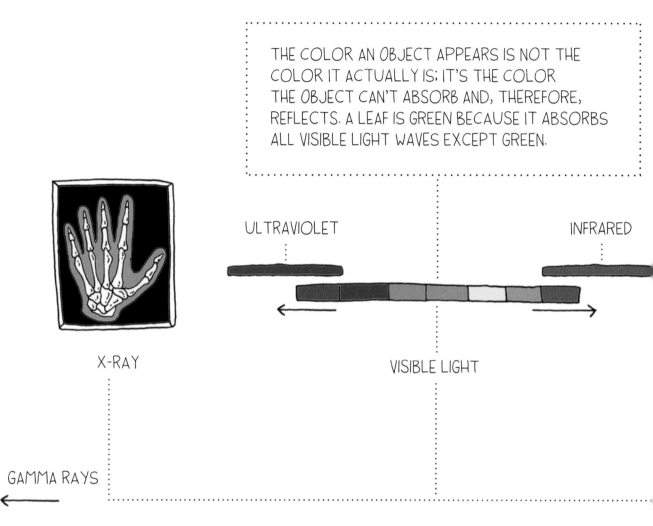

THE COLOR AN OBJECT APPEARS IS NOT THE COLOR IT ACTUALLY IS; IT'S THE COLOR THE OBJECT CAN'T ABSORB AND, THEREFORE, REFLECTS. A LEAF IS GREEN BECAUSE IT ABSORBS ALL VISIBLE LIGHT WAVES EXCEPT GREEN.

ULTRAVIOLET

INFRARED

X-RAY

VISIBLE LIGHT

GAMMA RAYS

Quick note on microwaves: IMAGINE YOU ARE VERY COLD. YOU ARE ALSO IN A ROOM WITH MANY OTHER COLD PEOPLE. YOU ALL BEGIN TO SPRINT BACK AND FORTH, BACK AND FORTH IN THE ROOM UNTIL THE ROOM IS HEATED UP AND SO ARE YOU (IF THE ROOM IS LEFTOVERS, SAY, FOR 5 MINUTES ON FASTEST SPEED). CONGRATULATIONS, YOU JUST ACTED KIND OF LIKE THE

Short wavelengths, higher frequency

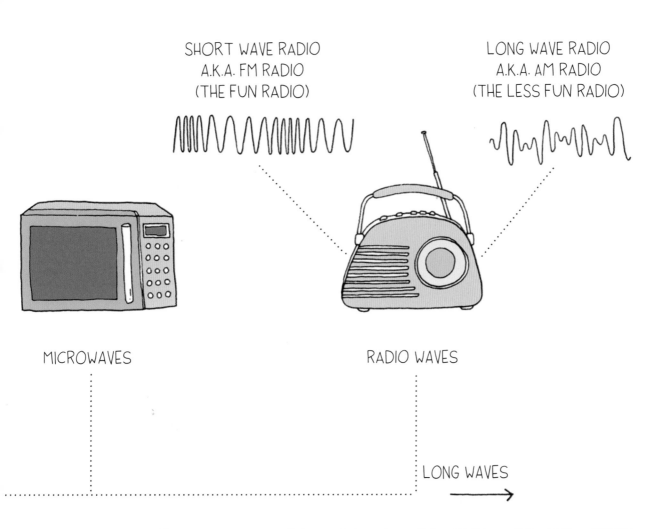

SHORT WAVE RADIO
A.K.A. FM RADIO
(THE FUN RADIO)

LONG WAVE RADIO
A.K.A. AM RADIO
(THE LESS FUN RADIO)

MICROWAVES

RADIO WAVES

LONG WAVES

POLARITY OF A WATER MOLECULE IN A POTATO BEING MICROWAVED! MICROWAVES AFFECT POLAR WATER MOLECULES IN YOUR FOOD, CHANGING THEIR MAGNETIC POLARITY BACK AND FORTH MILLIONS OF TIMES A SECOND, GENERATING ENERGY IN THE FORM OF HEAT, WHICH MAKES YOUR FOOD WARM.

Long wavelengths, lower frequency

Measuring pH
In a cabinet of gross liquids

0 (MOST ACIDIC) 7 NEUTRAL 14 (MOST BASIC)

THE pH SCALE MEASURES THE RATIO OF HYDROGEN IONS (H+) AND HYDROXIDE IONS (OH-) IN A GIVEN SOLUTION. ACIDIC SUBSTANCES HAVE CHEMICAL STRUCTURES THAT MAKE IT SO HYDROGEN MOLECULES BREAK AWAY WHEN IN WATER, INCREASING THE NUMBER OF HYDROGEN IONS (H+) IN THE SOLUTION. BASIC SUBSTANCES ACCEPT HYDROGENS FROM THE WATER ITSELF, INCREASING THE HYDROXIDE IONS (OH-) IN THE SOLUTION.

THE SCALE IS LOGARITHMIC, OR EXPONENTIAL, MEANING EACH INCREASE IN POINT ON THE SCALE IS TENFOLD THE CONCENTRATION OF HYDROGEN IONS IN THE SOLUTION. THE SCALE OF pH IS SHORTHAND FOR P (LOGARITHM) OF H (HYDROGEN ION CONCENTRATION). THIS MEANS THAT A SUBSTANCE WITH A pH OF 0 (VERY ACIDIC) COULD HAVE TRILLIONS MORE HYDROGEN IONS THAN A SUBSTANCE WITH A pH OF 14 (MOST BASIC).

WATER HAS A pH OF 7 (NEUTRAL). IN PURE WATER, THE RATIO IS EQUAL (TO BE SPECIFIC, THERE ARE 10^{-7} MOLES* / LITER), WHICH IS WHY WATER HAS A pH OF 7.

Row 1:
GRAPEFRUIT JUICE
LEMON JUICE
SALIVA
SODA
TOOTHPASTE

Row 2:
COFFEE
EGG
BAKING SODA
SEA WATER
TOMATO JUICE

Row 3:
URINE
FINGERNAILS
PEPTO BISMOL
SOAPY WATER
MILK

Row 4:
BLOOD
AMMONIA
WATER
BLEACH
BEER

Row 5:
DETERGENT
ACID RAIN
BATTERY ACID
DRAIN CLEANER
BILE

*MOLE: THE CONCENTRATION OF A SOLUTION IS COMMONLY EXPRESSED BY ITS MOLARITY, DEFINED AS THE AMOUNT OF DISSOLVED SUBSTANCE PER UNIT VOLUME OF A SOLUTION, TYPICALLY MOLES PER LITRE (MOL/L).

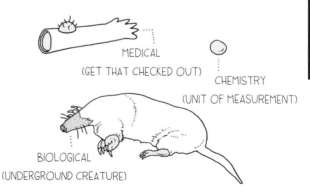

MEDICAL
(GET THAT CHECKED OUT)

CHEMISTRY
(UNIT OF MEASUREMENT)

BIOLOGICAL
(UNDERGROUND CREATURE)

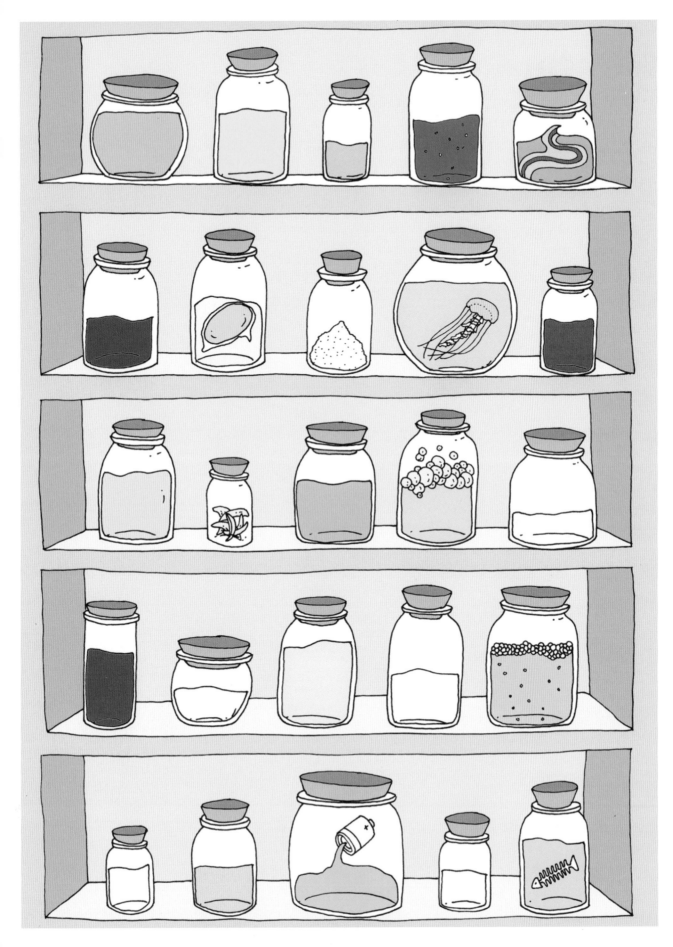

Carbon Dating
OKCupid for dinosaurs

LIVING THINGS ASSIMILATE CARBON-14 FROM CARBON DIOXIDE
THROUGHOUT THEIR LIVES. THE RATIO OF CARBON-14 TO CARBON-12 IN
LIVING THINGS IS CONSISTENT (ABOUT 1 TRILLION C-12S TO ONE C-14).
WHEN A CREATURE DIES, THE C-14 (A RADIOACTIVE ISOTOPE) IN THEIR
BODY STARTS DECAYING. IT DECAYS AT A CONSTANT RATE OVER A
HALF LIFE OF ABOUT 5,700 YEARS. SINCE THE C-12 REMAINS STABLE
IN THE BODY, THE AGE OF AN ORGANISM CAN BE CALCULATED BY
MEASURING THE RATIO OF C-14 TO C-12.

AFTER 40 TO 60,000 YEARS,
CARBON DATING IS NOT A VIABLE
MEASURING TOOL, SO OTHER
TYPES OF ISOTOPES CAN BE USED.

HOW CARBON DIOXIDE IS CREATED

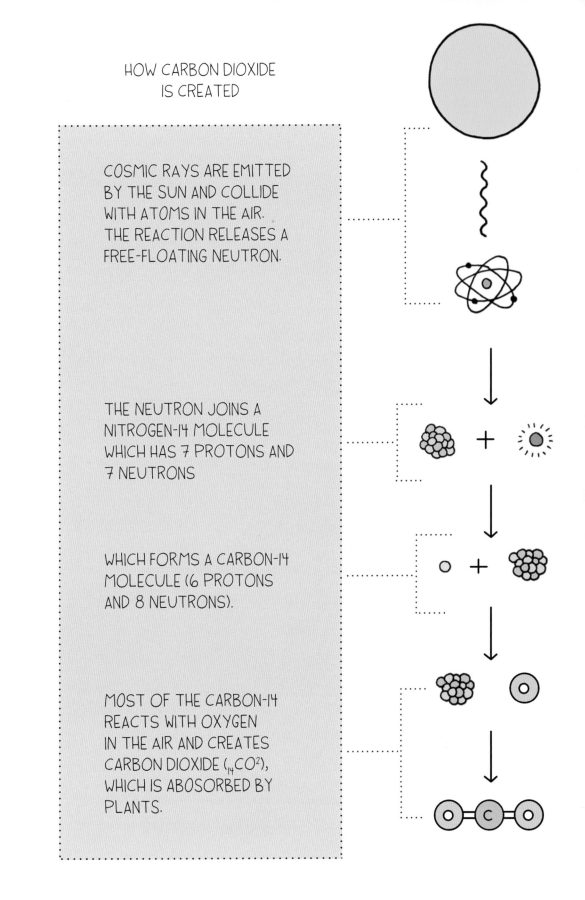

COSMIC RAYS ARE EMITTED BY THE SUN AND COLLIDE WITH ATOMS IN THE AIR. THE REACTION RELEASES A FREE-FLOATING NEUTRON.

THE NEUTRON JOINS A NITROGEN-14 MOLECULE WHICH HAS 7 PROTONS AND 7 NEUTRONS

WHICH FORMS A CARBON-14 MOLECULE (6 PROTONS AND 8 NEUTRONS).

MOST OF THE CARBON-14 REACTS WITH OXYGEN IN THE AIR AND CREATES CARBON DIOXIDE ($_{14}CO^2$), WHICH IS ABOSORBED BY PLANTS.

How Food Is Preserved
Eight ways to eat fish later

FOOD PRESERVATION TECHNIQUES EMPLOY CHEMISTRY TO THWART BACTERIA AND OXIDATION THAT CAUSE FOOD TO BECOME HARMFUL FOR CONSUMPTION.

THE GOAL OF MANY PRESERVING METHODS IS TO CREATE AN INHOSPITABLE ENVIRONMENT FOR MICROORGANISM GROWTH. METHODS INCLUDE: USING EXTREME HEAT AND COLD; ELIMINATING MOISTURE WITH SALT, SUGAR, OR DEHYDRATION; CHANGING THE pH WITH ACIDS; OR BLASTING IT WITH NUCLEAR RADIATION (WHICH SEEMS LIKE OVERKILL).

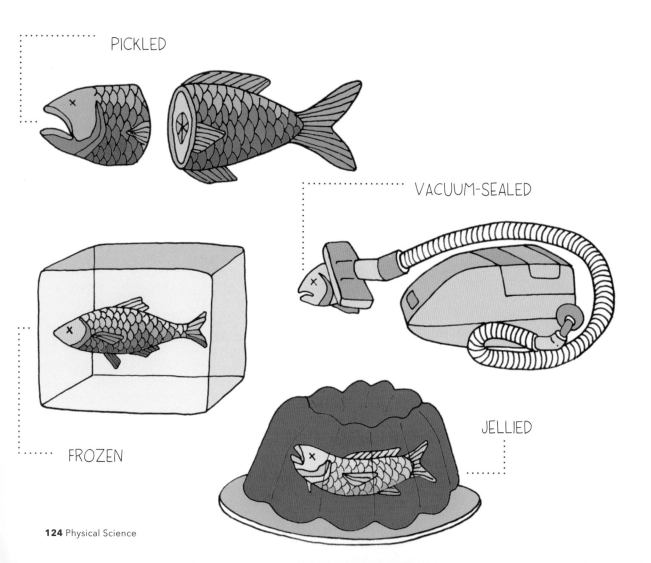

PICKLED

VACUUM-SEALED

FROZEN

JELLIED

THERE ARE THREE MAIN CATEGORIES OF PRESERVATION,
EACH AIMED TO HALT A DIFFERENT ROTTING AGENT.

Antimicrobials: HALTS THE GROWTH OF HARMFUL
BACTERIA, YEASTS, AND FUNGI.
Antioxidants: REDUCES THE SPEED OF OXIDATION.
Acids: SLOWS THE ENZYMES IN PRODUCE THAT ARE
RESPONSIBLE FOR RIPENING.

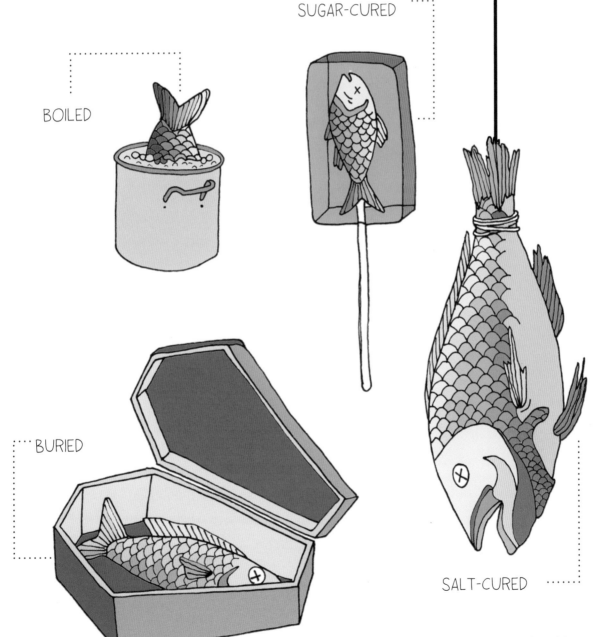

SUGAR-CURED

BOILED

BURIED

SALT-CURED

Mirrors
What the hell are they

TO UNDERSTAND MIRRORS, ONE MUST UNDERSTAND LIGHT. WE ONLY SEE LIGHT WHEN IT BOUNCES (REFLECTS) OFF A SURFACE AND REACHES OUR EYES.

ALL LIGHT OBSERVES THE LAW OF REFLECTION. INCOMING LIGHT HITS A SURFACE AT AN ANGLE (ANGLE OF INCIDENCE), AND THEN REFLECTS OFF THE SURFACE (ANGLE OF REFLECTION). THE ANGLE AT WHICH IT REFLECTS DEPENDS ON THE SURFACE TEXTURE. MOST OBJECTS OR SURFACES ARE NOT EXTREMELY SMOOTH, SO LIGHT REFLECTS IN MANY DIFFERENT DIRECTIONS, CALLED DIFFUSE REFLECTION.

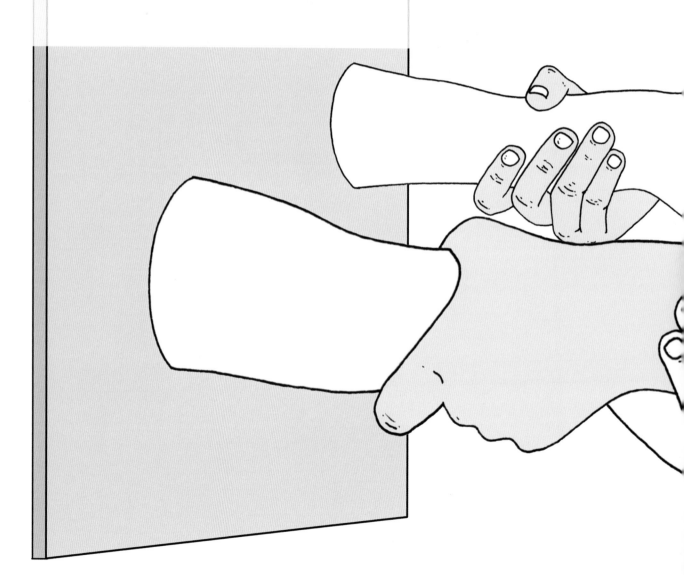

MIRRORS DO NOT SCATTER LIGHT AS THE SURFACE IS VERY SMOOTH AND REFLECTIVE (UNLIKE A PIECE OF SMOOTH FABRIC). A MIRROR HAS BLACK BACKING THAT PREVENTS ALMOST ALL LIGHT FROM ESCAPING. LIGHT REFLECTS AT THE SAME ANGLE AS IT CAME IN, KNOWN AS SPECULAR REFLECTION.

SO WHEN YOU LOOK AT YOURSELF IN THE MIRROR, THE LIGHT IS ENTERING (FROM YOU) AND EXITING (INTO YOUR EYES) AT THE SAME DEGREE. THE MIRROR APPEARS TO REVERSE THE IMAGE IT'S REFLECTING, BUT IT'S ESSENTIALLY MAKING A "LIGHT PRINT" OF YOU.

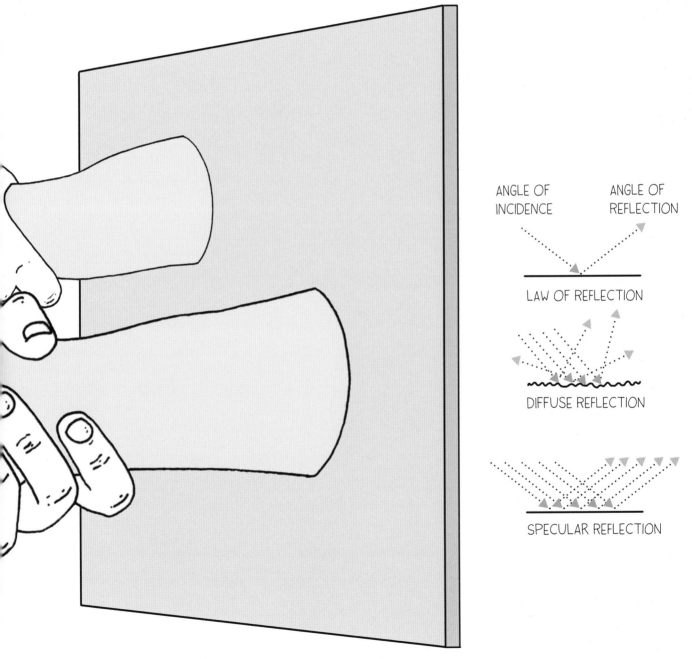

ANGLE OF INCIDENCE ANGLE OF REFLECTION

LAW OF REFLECTION

DIFFUSE REFLECTION

SPECULAR REFLECTION

Seeing Into The Past
How looking far is looking back

THE ANDROMEDA GALAXY IS THE FARTHEST THING
THE NAKED HUMAN EYE CAN SEE. THE GROUP OF ONE
TRILLION STARS IS LOCATED 2.6 MILLION LIGHT-YEARS
FROM OUR PLANET. BECAUSE IT TAKES LIGHT SO LONG
TO TRAVEL THROUGH THE VAST DISTANCES OF SPACE,
THE LIGHT THAT WAS EMITTED 2.6 MILLION YEARS AGO
IS JUST NOW REACHING OUR EYES, MEANING THAT
LOOKING AT ANDROMEDA IS ESSENTIALLY LOOKING INTO
THE PAST.

Near Side Of The Moon
The only side we know

SO, WHY DO WE ONLY SEE ONE SIDE OF THE MOON?
THE OTHER SIDE IS SHY? SELF-CONSCIOUS? ASLEEP?
 MAYBE ALL OF THOSE, BUT IT IS ALSO IN A FIXED
ORBIT WITH EARTH KNOWN AS SYNCHRONOUS
ROTATION SO THAT THE MOON'S SPIN AROUND
ITS AXIS IS THE SAME RATE AS THE MOON'S ORBIT
AROUND EARTH.
 WE ONLY SEE THE MOON BECAUSE THE SUN
REFLECTS ON IT. SO WHEN THE MOON IS BETWEEN
EARTH AND THE SUN, IT'S A NEW MOON (SUN IS
ON THE MOON'S BACK), AND WHEN THE EARTH IS
BETWEEN THE SUN AND MOON, IT'S A FULL MOON.

MOON SPINS AROUND
EARTH AT SAME RATE AS
IT SPINS AROUND ITSELF

EARTH SPINS AROUND
ONCE A DAY

SUN STAYS PUT

EARTH ORBITS SUN
ONCE A YEAR

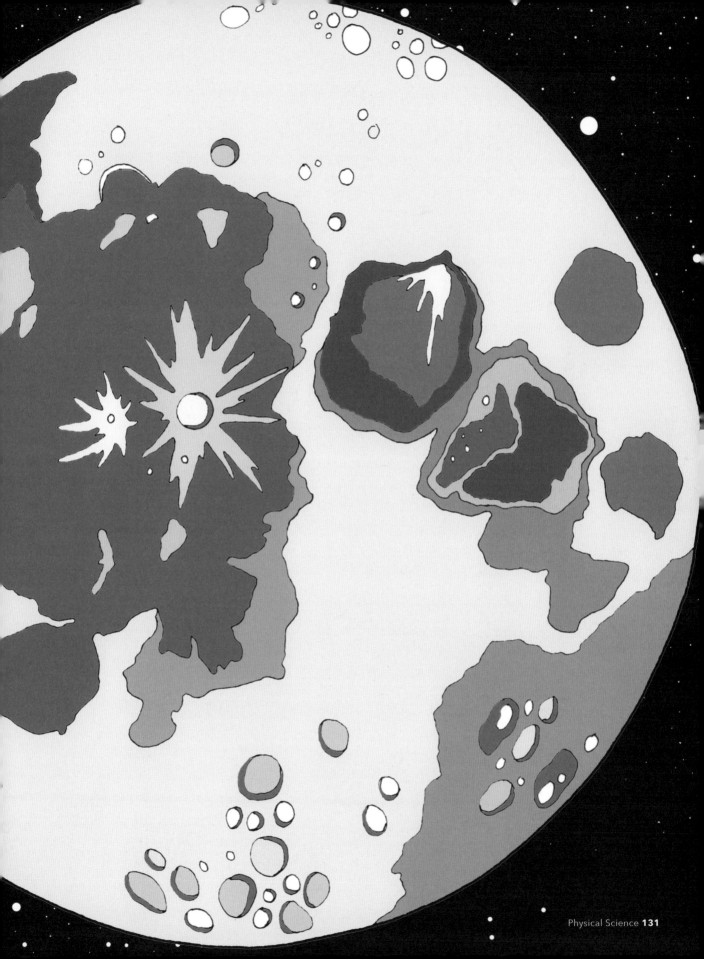

The Universe
A brief index

UNIVERSE ··········

SUPERCLUSTER

CLUSTER

GALAXY ········

SOLAR SYSTEM ·····

STAR ················

PLANET ···············

MOON ················

ASTEROID ············

COMET ···············

THE ZONE OF AVOIDANCE (WHERE NON-CONFRONTATIONAL
STARS HANG OUT) IS THE AREA OF OBSERVABLE SKY
(ABOUT 20 PERCENT) THAT APPEARS TO BE DEVOID OF GALAXIES.
GAS AND DUST FROM THE MILKY WAY BLOCK THE LIGHT
FROM DISTANT GALAXIES.

THE HERCULES-CORONA BOREALIS GREAT WALL
IS THE LARGEST KNOWN COSMIC STRUCTURE.
(IT'S 10,000,000,000 LIGHT-YEARS ACROSS.)

Cosmic Distance Ladder
Climbing into the abyss

THE COSMIC DISTANCE LADDER IS AN ANALOGY THAT DESCRIBES
THE METHODS USED TO MEASURE HUGE (ASTRONOMICAL)
DISTANCES IN SPACE. TO BE ABLE TO MEASURE A FAR, FAR,
FARAWAY OBJECT (ANOTHER GALAXY), YOU MUST FIRST KNOW
HOW TO MEASURE A FAR, FARAWAY OBJECT (SOMETHING ON THE
OUTSKIRTS OF OUR GALAXY).

BUT BEFORE THAT YOU MUST KNOW HOW TO MEASURE A
FARAWAY OBJECT (A PLANET IN OUR SOLAR SYSTEM).

YOU MAY ONLY CLIMB THE LADDER ONE RUNG AT A TIME.

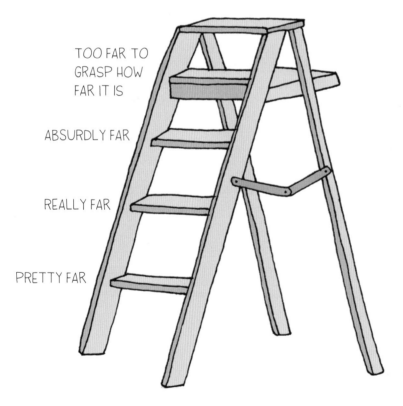

TOO FAR TO
GRASP HOW
FAR IT IS

ABSURDLY FAR

REALLY FAR

PRETTY FAR

Note: Ladder not drawn to scale

ASTRONOMY DOESN'T HAVE A SINGLE UNIT OR TECHNIQUE THAT CAN BE APPLIED TO ALL MEASURABLE DISTANCES. DIRECT MEASUREMENT CAN ONLY BE USED FOR OBJECTS THAT ARE RELATIVELY CLOSE TO THE EARTH.

HERE ARE SOME METHODS USED TO CALCULATE ASTRONOMICAL DISTANCES:

Astronomical unit: THE DISTANCE BETWEEN THE EARTH AND SUN. ASTRONOMICAL UNITS ARE USED TO MEASURE DISTANCES WITHIN OUR SOLAR SYSTEM.

Radio detection and ranging (RADAR): RADAR USES ELECTROMAGNETIC WAVES TO DO A SORT OF LARGE-SCALE ECHOLOCATION. AN ANTENNA SENDS OUT RADIO WAVES OR MICROWAVES AND GATHERS INFORMATION BASED ON THE WAVES THAT BOUNCE BACK. RADAR MEASURES FARTHER DISTANCES, SUCH AS FROM THE EARTH TO VENUS OR FROM THE EARTH TO ASTEROIDS. IT USES COMPARISONS OF THE EARTH AND OTHER CELESTIAL BODIES TO CALCULATE DISTANCES. RADAR HAS HELPED TO CALCULATE THE EARTH'S ORBIT WITH GREAT PRECISION, TO WITHIN A FEW METERS.

Trigonometric parallax: IMAGINE LOOKING AT AN APPLE WITH BOTH EYES. THEN CLOSE THE LEFT EYE AND LOOK WITH JUST THE RIGHT. THEN SWITCH EYES AND LOOK AGAIN. THE APPLE APPEARS TO SHIFT POSITIONS WHEN YOU ALTERNATE. YOUR TWO EYES AND THE APPLE FORM A TRIANGLE. THIS IS A VERY SMALL-SCALE VERSION OF PARALLAX. THE EARTH'S ORBIT (ITS POSITION TO THE LEFT AND RIGHT OF THE SUN) IS USED AS A BASELINE WHEN CALCULATING THE DISTANCE OF A THIRD COSMIC OBJECT.

Standard candle: AN ASTRONOMICAL OBJECT OF KNOWN ABSOLUTE MAGNITUDE (BRIGHTNESS) WHICH IS ASSUMED TO NOT VARY WITH AGE OR DISTANCE. IF WE KNOW HOW BRIGHT A LIGHT BULB IS 5 FEET FROM US (LET'S SAY 40 WATTS), WE CAN FIGURE OUT THE DISTANCE OF ANOTHER LIGHT BULB THAT APPEARS TO BE 5 WATTS USING THE KNOWN LUMINOSITY OF THE LIGHT AT A STANDARD DISTANCE.

Variable cepheid stars: FOR USE WITH CLOSER COSMIC OBJECTS (WITHIN OUR GALAXY OR NEIGHBORING GALAXIES). IF OBJECTS ARE OVER 1 BILLION LIGHT YEARS AWAY, ASTRONOMERS USE TYPE IA SUPERNOVAE, WHOSE EXPLOSIONS ALWAYS PRODUCE THE SAME BRIGHTNESS (5 BILLION TIMES AS BRIGHT AS THE SUN).

The Ten Dimensions
Of string theory pt. 1

CONSIDER FOR A MOMENT THAT YOU ARE WHAT PHYSICISTS CALL A FLATLANDER — YOU EXPERIENCE THE WORLD ONLY IN TWO DIMENSIONS. LET'S PRETEND FLATLAND IS A PIECE OF PAPER. NOW LET'S IMAGINE THAT A HOLLOW RUBBER BALL COULD FALL THROUGH IT VERTICALLY. THE FLATLANDER (YOU) COULD ONLY UNDERSTAND THE BALL AS "SLICES" THAT PASS THROUGH THE PAPER, STARTING AS A DOT, THEN CIRCLES GROWING IN DIAMETER, THEN REDUCING IN SIZE DOWN TO ANOTHER DOT. THEY COULDN'T UNDERSTAND THE CONCEPT OF A BALL WITH THE ADDED DIMENSION OF DEPTH. THIS IS WHY ADDITIONAL DIMENSIONS ARE HARD TO CONCEPTUALIZE FOR US THREE-DIMENSIONALERS. WITHOUT THE PROPER CONTEXTUAL RULES, WE CANNOT UNDERSTAND THE FULL SYSTEM.

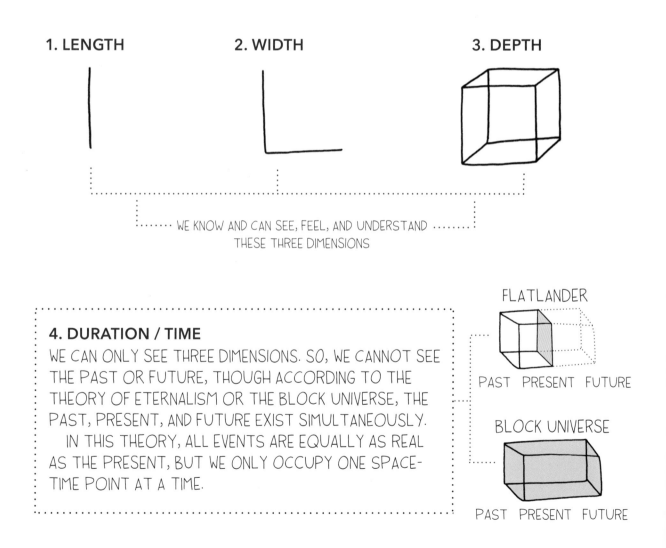

1. LENGTH **2. WIDTH** **3. DEPTH**

WE KNOW AND CAN SEE, FEEL, AND UNDERSTAND THESE THREE DIMENSIONS

4. DURATION / TIME
WE CAN ONLY SEE THREE DIMENSIONS. SO, WE CANNOT SEE THE PAST OR FUTURE, THOUGH ACCORDING TO THE THEORY OF ETERNALISM OR THE BLOCK UNIVERSE, THE PAST, PRESENT, AND FUTURE EXIST SIMULTANEOUSLY.
IN THIS THEORY, ALL EVENTS ARE EQUALLY AS REAL AS THE PRESENT, BUT WE ONLY OCCUPY ONE SPACE-TIME POINT AT A TIME.

FLATLANDER

PAST PRESENT FUTURE

BLOCK UNIVERSE

PAST PRESENT FUTURE

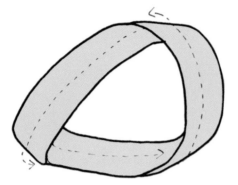

IMAGINE YOU ARE A FLATLANDER WALKING ON A MOBIUS STRIP. IT SEEMS LIKE YOU ARE MOVING LINEARLY FORWARD ON A FLAT SURFACE. WE AS THE FLAT 2-D PERSON ARE UNAWARE OF OUR MOVEMENT IN THE DIMENSION ABOVE. THE 2-D VERSION OF US MOVING ON A 3-D SURFACE IS COMPARABLE TO US IN 3-D MOVING THROUGH TIME.

5. A MULTITUDE OF VARIED SELVES

YOU AS A MEDIOCRE BASSIST

YOU RIGHT NOW, AS A DENTIST

YOU DECIDING TO GO TO DENTAL SCHOOL OR JOIN A ROCK BAND

6. THE ABILITY TO JUMP FROM ONE FIFTH-DIMENSION SELF OPTION TO ANOTHER ONE.

OH, HELLO, OTHER POTENTIAL LIFE

FOLDING THE FIFTH

A FOLD

MOVING TO A VERY DIFFERENT PLACE WITHOUT MOVING VERY MUCH

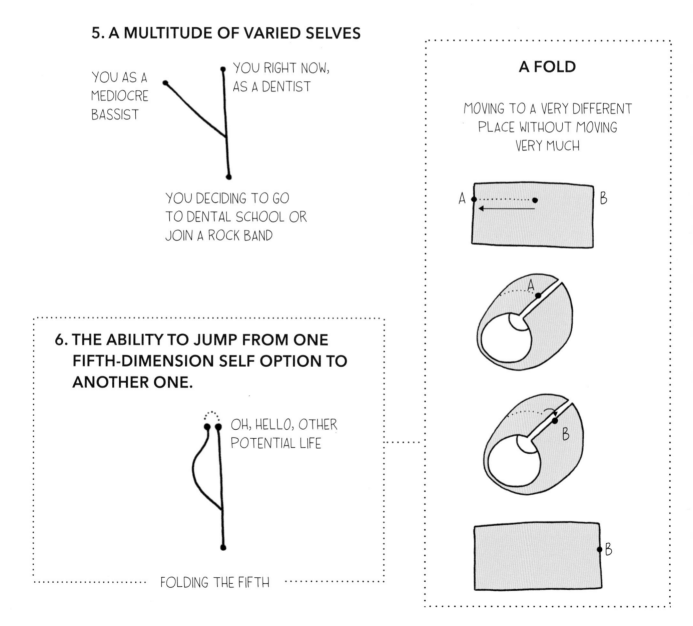

A ● ←————————— B

A

B

B

The Ten Dimensions
Of string theory pt. 2

7. ALL POSSIBLE OPTIONS/ OUTCOMES SINCE THE BIG BANG (WITH THE SAME INITIAL CONDITIONS)

BIG BANG

8. DIFFERENT POSSIBLE INFINITIES STARTED BY DIFFERENT INITIAL CONDITIONS WITH DIFFERENT PHYSICAL LAWS

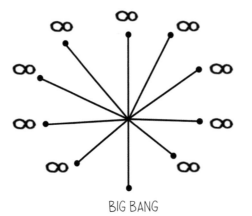

BIG BANG

9. THE ABILITY TO JUMP FROM ONE
8TH DIMENSION INFINITY OPTION
TO ANOTHER ONE

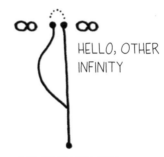

HELLO, OTHER
INFINITY

FOLDING THE 8TH

10. ALL POSSIBLE OUTCOMES WITH
ALL POSSIBLE INITIAL CONDITIONS
AND ALL POSSIBLE PHYSICS LAWS

The Ten Dimensions
Of string theory pt. 3

A point: A LOCATION IN A SYSTEM OF INDETERMINATE SIZE. THIS COULD BE A STRAWBERRY SEED UP CLOSE OR A SINKHOLE AS SEEN FROM SPACE.

IMAGINE DRAWING EVERY POSSIBLE RADIUS WITHIN A CIRCLE, STARTING FROM THE CENTER POINT. EVENTUALLY, THE NUMBER OF LINES BECOMES SO DENSE IT COMPLETELY FILLS IN THE PREVIOUSLY EMPTY CIRCLE.

NOW, ASSUME THAT CENTER POINT IS YOUR STARTING CONDITION, AND ALL THE RADIATING LINES ARE THE POSSIBILITIES DESCRIBED IN DIMENSIONS 1 THROUGH 9. IF YOU HAVE ENOUGH BRANCHING POSSIBILITIES, EVENTUALLY IT CREATES A POINT FROM WHICH YOU BEGIN AGAIN WITH IT AS THE CENTER POINT TO YOUR RADIATING LINES. INFINITE OPTIONS.

A Singularity
The biggest tiny thing in the universe

A SINGULARITY IS A SINGLE, ONE-DIMENSIONAL
POINT THAT CONTAINS INFINITE DENSITY

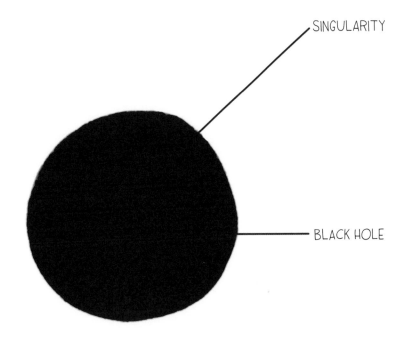

SINGULARITY

BLACK HOLE

A SINGULARITY IS FOUND IN THE
CENTER OF A BLACK HOLE

The Spaghettification Theory
A.K.A. the noodle effect
A.K.A. space pasta
A.K.A. sure death

BEFORE

A BLACK HOLE IS THE GHOST FORMED FROM THE DEATH OF A LARGE STAR. THE GRAVITATIONAL PULL OF A BLACK HOLE IS SO GREAT THAT IT STRETCHES ANYTHING THAT APPROACHES, ESSENTIALLY SHREDDING IT INTO SPAGHETTI.

AFTER

Vacuums
Creating nothingness, then filling it with dog hair

A VACUUM IS A SPACE THAT IS VOID OF MATTER. A TRUE PERFECT VACUUM HAS NO PARTICLES.

DEEP SPACE IS THE CLOSEST THING TO A PERFECT VACUUM, MUCH CLOSER THAN ANY ARTIFICIALLY LAB-MADE VACUUMS.

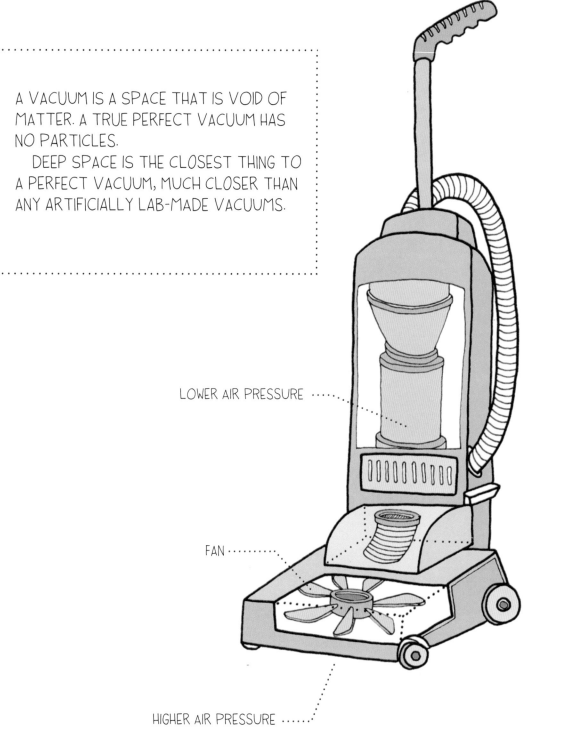

LOWER AIR PRESSURE

FAN

HIGHER AIR PRESSURE

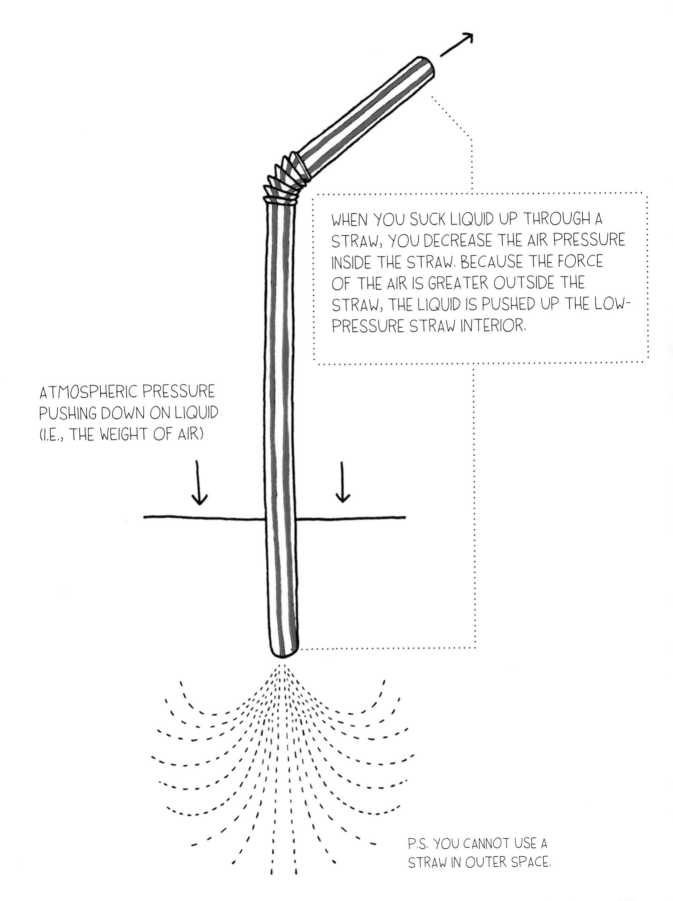

WHEN YOU SUCK LIQUID UP THROUGH A STRAW, YOU DECREASE THE AIR PRESSURE INSIDE THE STRAW. BECAUSE THE FORCE OF THE AIR IS GREATER OUTSIDE THE STRAW, THE LIQUID IS PUSHED UP THE LOW-PRESSURE STRAW INTERIOR.

ATMOSPHERIC PRESSURE PUSHING DOWN ON LIQUID (I.E., THE WEIGHT OF AIR)

P.S. YOU CANNOT USE A STRAW IN OUTER SPACE.

Index

Acknowledgments

THANK YOU TO MY WONDERFUL EDITOR, SARAH, FOR GIVING ME THE FREEDOM TO TRANSLATE MY BRAIN ONTO PAPER AND BELIEVING IT WOULD TURN OUT GREAT. TO KATE FOR HELPING CULTIVATE IDEAS, CONFIDENCE, AND PAPERWORK. TO BUNNY FOR BEING USELESS, BUT CUTE. TO PAUL WHO GENEROUSLY MADE SURE MY SCIENCE WAS ACCURATE. TO CLAIRE AND CASSY FOR ENDLESS SUPPORT IN EVERY REALM OF LIFE, INCLUDING BOOK MAKING. TO ALL THE PEOPLE IN THE WORLD WHO LOVE SCIENCE AND TO THOSE WHO DON'T KNOW THEY LOVE IT (YET).

Iris Gottlieb is a freelance illustrator and layman scientist. Originally from the South, and currently residing in the Bay Area, she grew up collecting dead and living things and has continued to do so, documenting and researching them along the way. She has collected 3,614 shark teeth. When not exploring, Iris works with museums, publications, groups, and individuals as a freelance illustrator, animator, and graphic recorder. Previous gigs include residencies at the San Francisco Exploratorium's Tinkering Studio, the Oakland Museum of California, and Autodesk, and work for *Smithsonian* magazine, *826 Valencia*, *The Urban Death Project*, and more. She has one other book, *Natural Attraction: A Field Guide to Friends, Frenemies and Other Symbiotic Animal Relationships*.